IMAGES
of America

DOWNTOWN
ST. LOUIS

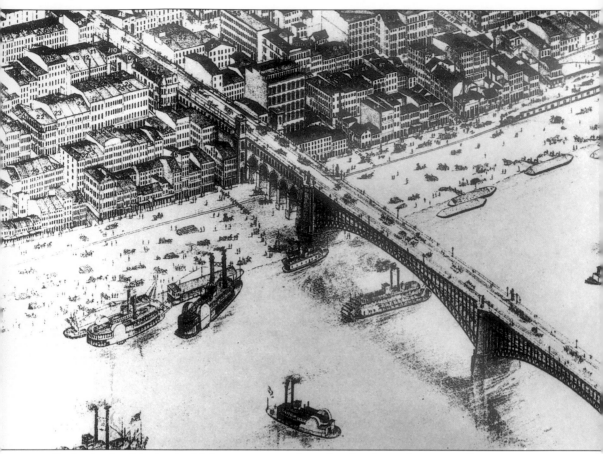

St. Louis wharf during its 19th-century steamboat days bustles with river traffic.

IMAGES
of America

DOWNTOWN
ST. LOUIS

Albert Montesi and Richard Deposki

ARCADIA
PUBLISHING

Copyright © 2001 by Albert Montesi and Richard Deposki
ISBN 978-0-7385-0816-0

Published by Arcadia Publishing
Charleston, South Carolina

Printed in the United States of America

Library of Congress Catalog Card Number: 2001091376

For all general information contact Arcadia Publishing at:
Telephone 843-853-2070
Fax 843-853-0044
E-mail sales@arcadiapublishing.com
For customer service and orders:
Toll-Free 1-888-313-2665

Visit us on the Internet at www.arcadiapublishing.com

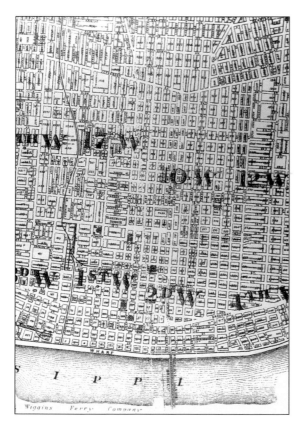

Shown here is an 1870s map of the
downtown area.

CONTENTS

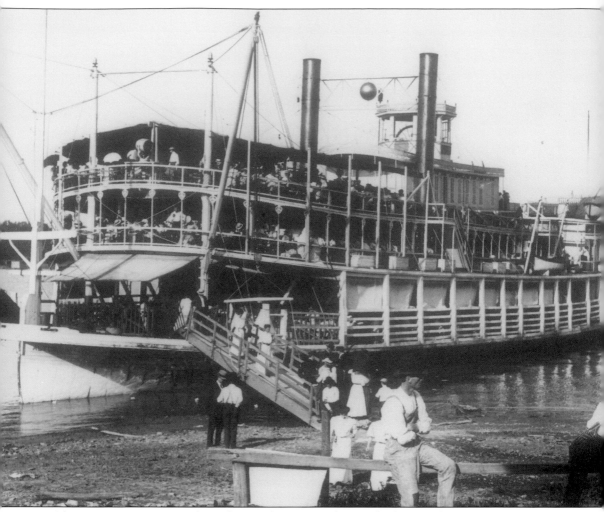

Above is a St. Louis steamboat that made runs to Alton and other nearby river towns.

ACKNOWLEDGMENTS

We wish to thank the following for their generous contributions to this book: special thanks go to Skip Gatermann, Frank E. Janson at the Metropolitan Sewer District, Jefferson Camera Shop, Sharon A. Huffman and Gloria Harris at the St. Louis Public Schools Record Center/ Archives, Lona Griffin, F. Crawford, Caroline Dohrendorf, School Sisters of Notre Dame, St. Louis Public Library Special Collections, St. Louis University Archives, Washington University Archives, St. Louis Carriage Co., Innovations for Kitchen & Bath, Jefferson National Expansion Memorial, NPS and Jennifer Rawlings.

INTRODUCTION

When we finger the clues as to what made St. Louis the first great city in the Middle West, certain factors come to mind. First and foremost was its connection with the vast river that flowed before it. St. Louis may well be called the consort of the Mississippi, for it is the city's connection with this great waterway that gave her life and sustenance. In the city's beginning and in her present state, her lifelines have always been nourished by the river.

From her founding when the French fur trader Pierre Laclede Liguest and his 14-year-old nephew Rene Auguste Chouteau first gazed upon the site of the future city in 1763, it was the river that had brought them. Commissioned by the Spanish government to establish a fur trading center, Laclede and his company returned in 1764 to establish the first settlement on the new land. They build houses and early primitive churches and forts. From the river came traders of all sorts—Indians, French, Spanish—to provide the city with its first role as a commercial center. The fur trade grew enormously, and even John Jacob Astor had a hand in it.

To add to this business activity was the appearance of the steamboat on the giant river. With the arrival of this superior mode of transportation, the city began to grow as a riverport. In time its river-front landing became the bustling center for these fast boats; scores of them would line up on the river to gain entrance to the city. As the traffic of the steamboat continued, the city became the center of the distribution of commodities such as cotton and fur, or other items that were manufactured in the new commercial town.

But the river was not always this benign. It began on various occasions to flood the landing and creep up to the warehouses that lined the docks. The city, known for its high protective bluffs, became vulnerable after these bluffs were destroyed. So vulnerable did the town become that in 1844, flood waters threatened the very heart of the business downtown area. In 1849, a steamboat catching fire was swept by high winds so that its flames fed fire to other docked boats and finally to the warehouses and then to the city itself. The result was disastrous: a good part of the town was destroyed. In the same year the river traffic brought to the city its most tragic misfortune: a cholera epidemic that swept the town, killing thousands of citizens.

Another factor that may have contributed to St. Louis' growth and development was of course its ideal position as a roadway to the West, to the nation, and finally to the world. By virtue of its miraculous Eads Bridge, and later its active railroad station (at one time one of the busiest in the world), and finally its progress and pioneer advances in aviation, it became one of the most metropolitan cities in the new world.

Another significant factor was that St. Louis was blessed with a group of farseeing men whose activities not only provided the city with authority and learning, but with some elegance and grace. One thinks of David Francis, August Busch, Wm Greenleaf Eliot, Charles Lindbergh, James Eads, the German Hegelians, the magnificent Victorian architecture, the universities, the Jesuits, Forest Park, the Mercantile Library, the Gateway Arch, and many other figures and institutions. These men and these projects brought to the city a cultural tone that was rare in

the growing Middle West.

But sadly during the years of the great Depression and World War II, St. Louis went into a period of decline. This we have recorded with scores of images of grand old buildings falling into decay and whole sections of town becoming blighted and deserted. Later with its population plummeting as people moved to the country, the city lost much of its old grandeur and flavor. But recently it seems to have recovered some of its lost life and color. New housing areas, revitalized neighborhoods, even new museums have began to emerge as young people seem to return to the city in moderate numbers. Yet if the city is to live it needs more than these small improvements. The task for the future is for progress to be more aggressive and the city more inviting. This is its challenge and hope.

One

BEGINNINGS

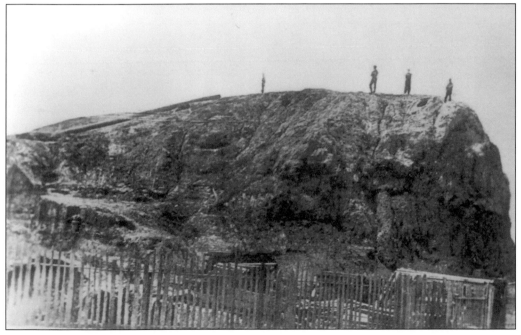

La Grange de Terre (the Earthern Bowl) was one of the 27 Indian burial mounds that the settlers first encountered in 1764 when they arrived on the site that was later to become St. Louis. These massive structures stood before Pierre Laclede and his nephew, Auguste Chouteau, as they surveyed the place that later would become a fur trading outpost. In a religious capacity, they existed as ceremonial burial mounds of some past superior Indian culture. In arrangement, they formed a group dotting the shoreline of the grand Mississippi as it flowed past the landing.

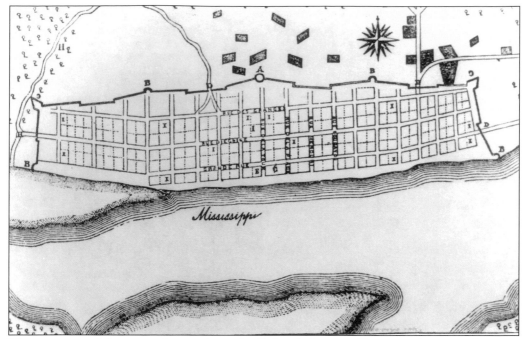

This is a copy of the original map, drawn by Colonel Auguste Chouteau, depicting the town as it appeared in 1764.

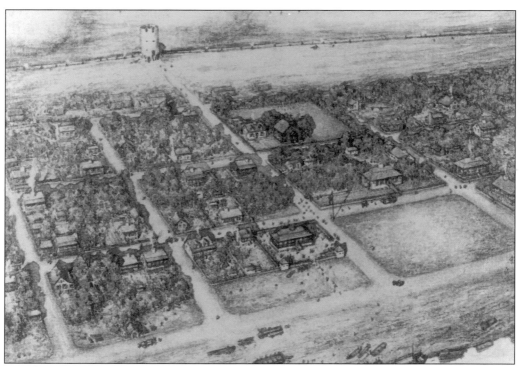

Seen here is a drawing of early St. Louis as it looked in 1780, at the time of the British-Indian attack on St. Louis. In this skirmish, the settlers fought off the attack. In the background one can see Fort San Carlos, built to fortify the settlement.

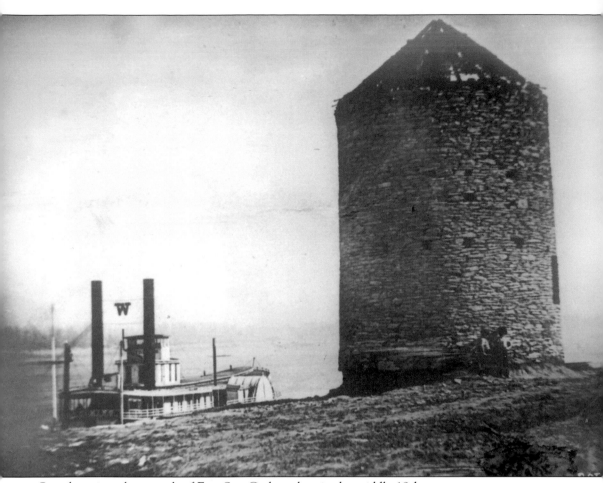

Seen here is a photograph of Fort San Carlos taken in the middle 19th century.

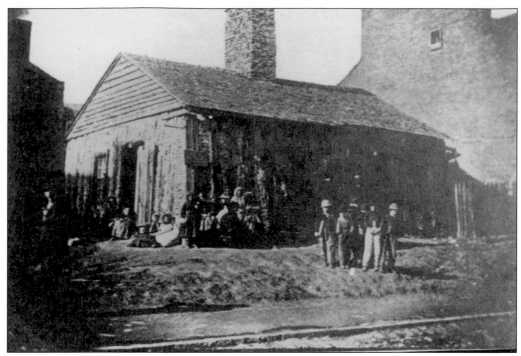

The old Bienvenne house, built in 1770, was a characteristic abode of the times. It was used as the first St. Louis courthouse from 1817–1820.

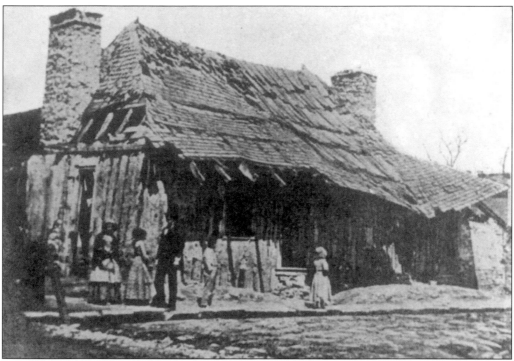

Shown here is the St. Louis residence of Alexander M'Nair, the first Missouri governor. He was inaugurated on September 18, 1820.

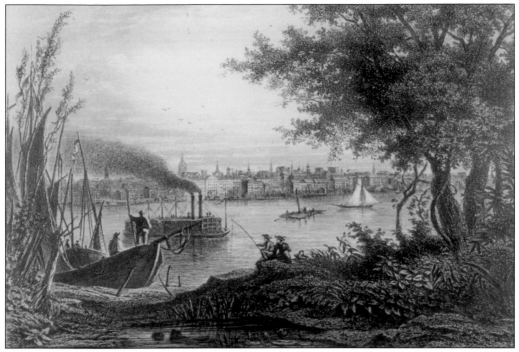

This steel engraving depicts the serene and lyrical side of the mighty Mississippi as it gently flowed past St. Louis in 1869.

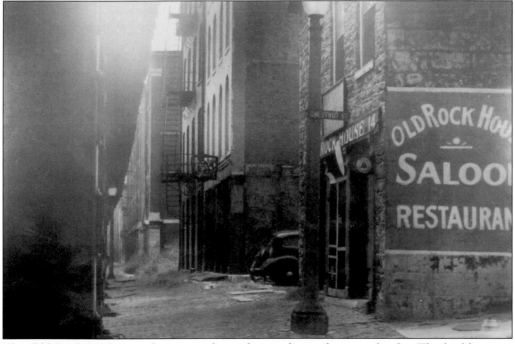

The Old Rock House was first erected as a fur warehouse for animal pelts. The building was later rebuilt and turned into a saloon in 1890. Famous black musicians, such as W.C. Handy, frequently performed there.

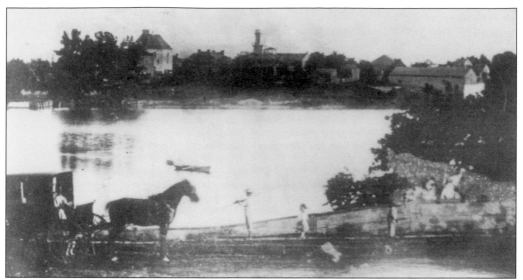

Chouteau's Pond was created by the waters of Mill Creek and springs. It was partially engineered by the damming of these waters as they flowed towards the Mississippi. Once the delight, as pictured here, of early 19th century St. Louis, it was deemed polluted after the cholera attack of 1849 and was drained.

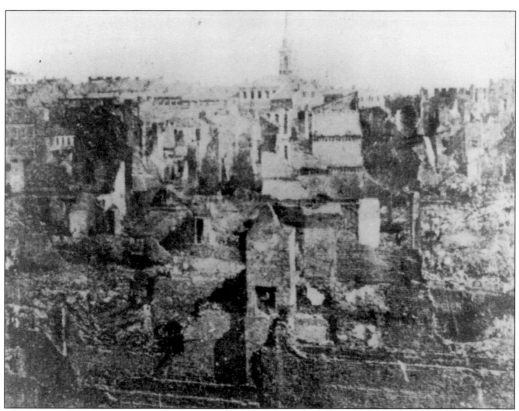

Seen here is the damage inflicted by the great fire of 1849, which swept from a burning steamboat to the entire city. It demolished almost all of downtown St. Louis.

Two

THE MISSISSIPPI RIVER

The beginning of the steamboat traffic on the St. Louis waters occurred as early as the 1830s. But the grand era of the steamboat with its paddle wheels, pilot house, and twin smoke stacks began for St. Louis roughly from 1870 to 1890. During that period, steamboats crowded the wharves of St. Louis to such a degree that the city became the third largest port in the nation. However, with the coming of the railroads and the more practical tugboats, both of which handled freight more effectively, the steamboat soon became outmoded.

Nonetheless, it remained a romantic spot in most sensibilities by virtue of it having been also a passenger ship beside the handling of freight. With elaborate salons, gambling, and stage productions, it may have acted as the river equivalent of the great ocean liners of later days. But the boats did not disappear entirely; some were turned into vast luxury passenger ships that entertained hundreds of riders each year. They were utilized in this fashion, in and out of St. Louis, for decades.

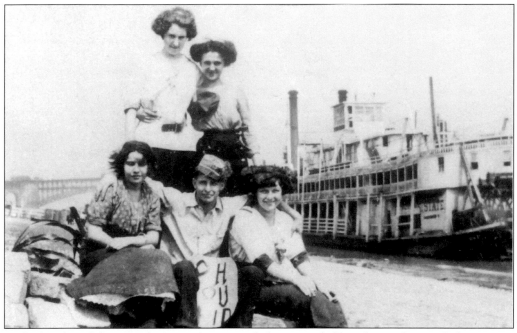

In the heyday of the steamboat era this young lad, surrounded by a bevy of young ladies, enjoys the good life on the St. Louis riverfront landing.

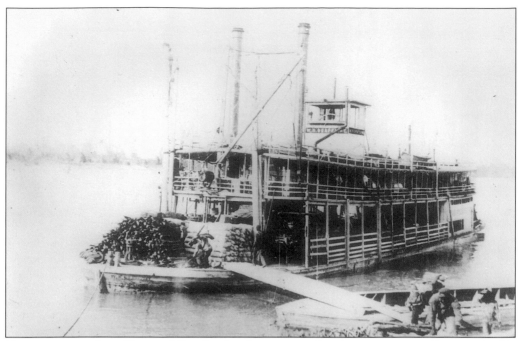

Here is a view of a gallant paddle wheeler about to conduct business as it pulls in at the St. Louis port.

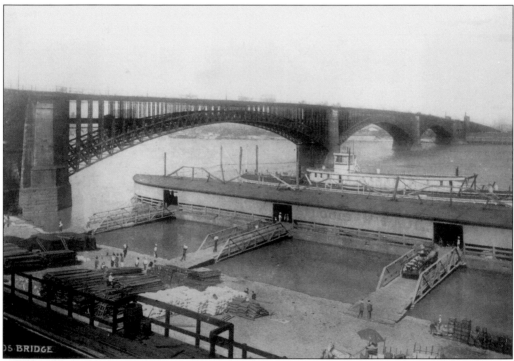

The Eads Bridge at the turn of the century is seen with the boats now replacing the old steamships as these new conveyances cross under the famed structure

Although difficult to detect in this 1913 photo, sewage was being piled into the Mississippi by the tons at the beginning of the 20th century. As the railroads became the major form of transportation in the late 19th century, St. Louis desperately needed some sort of bridge to join the Illinois side with St. Louis if it were to become a major player in the transportation industry. It was necessary to carry the new rail traffic of the locomotives over the 1,500 feet of river that separated the two states. An enterprising and resourceful engineer, James B. Eads, created one of the astonishing engineering feats of the times: the famed Eads bridge, which opened to the public in 1874. This structure, classical in appearance, became one of the great achievements of the era, and remains in use to this very day.

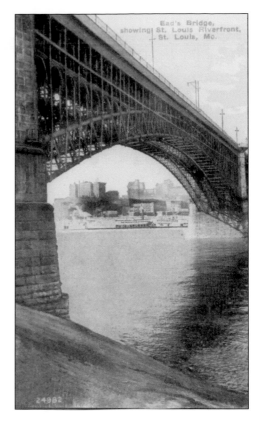

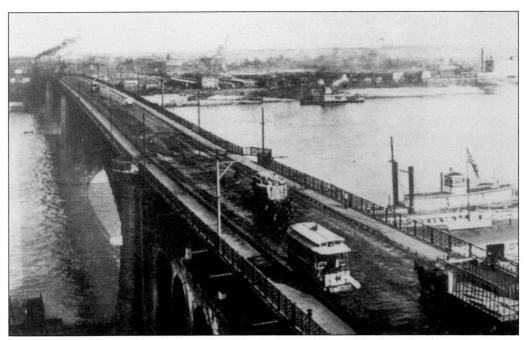

The famed Eads Bridge depicted here with its major traffic moving over it in the early 1900s.

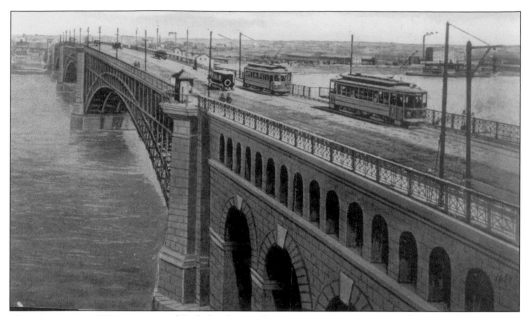

Here again is a 1924 picture of Eads bridge with its streetcar and auto traffic.

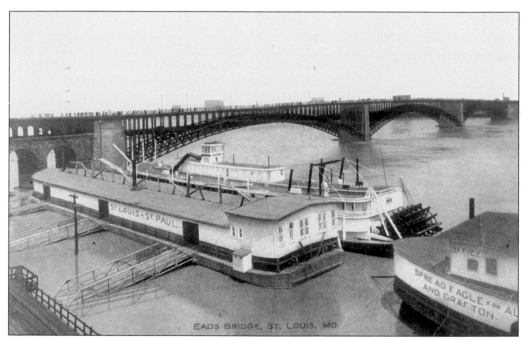

This Eads Bridge photo was taken at the turn of the century.

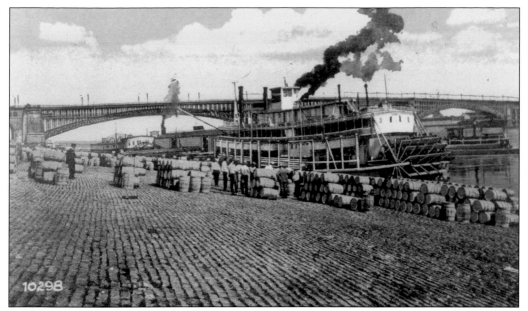

St. Louis in the 19th and early 20th centuries was one of the greatest exporters of cotton in the country. Here we see bales of cotton as they were stored on the cobblestone riverfront in 1924.

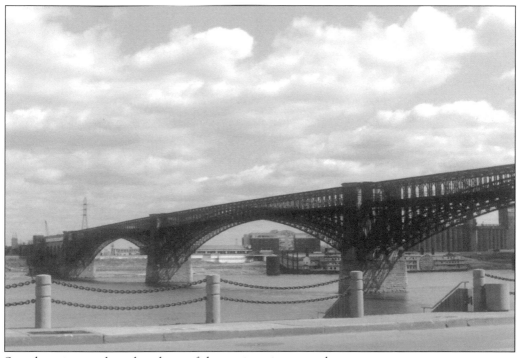

Seen here is a modern-day photo of the engineering marvel.

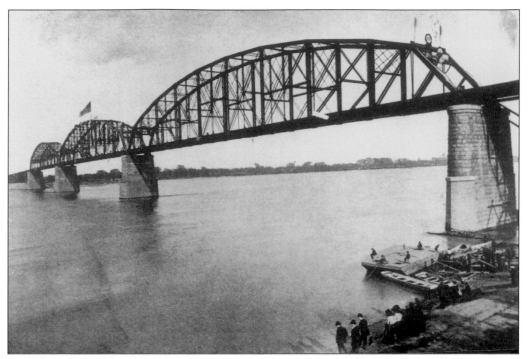

A stark and clear image of an early St. Louis bridge, the so-called Merchant's Bridge, is seen here in the early 1900s.

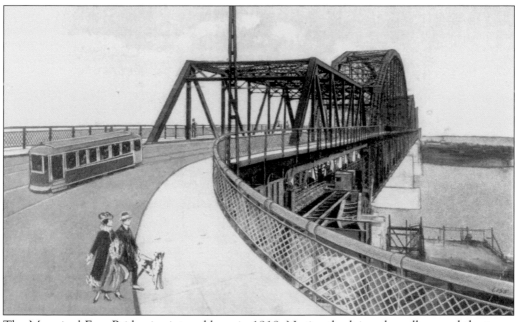

The Muncipal Free Bridge is pictured here in 1918. Notice the leisurely walkers and the tram.

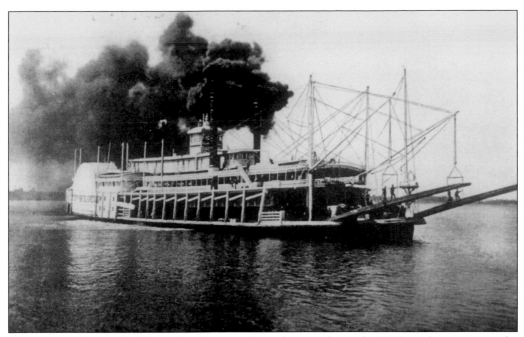

An excursion boat, *The City of St. Louis*, is shown here in the early 1900s with its twin smoke stacks belching out clouds of smoke.

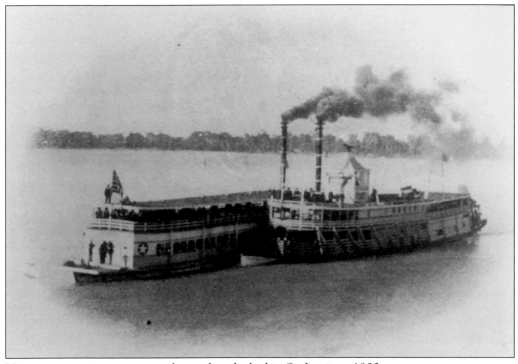

Here we see various excursion boats that docked in St. Louis, *c.* 1900.

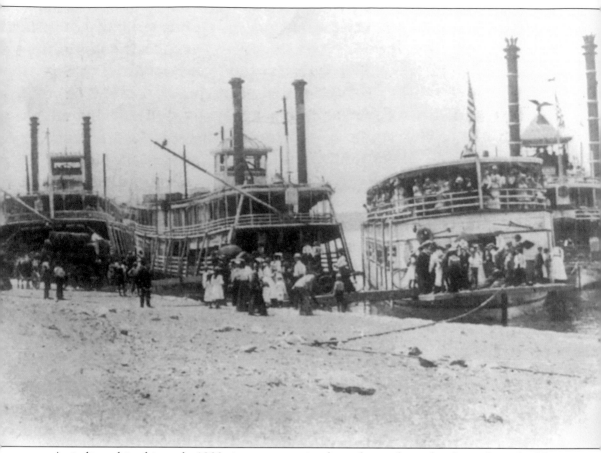

As indicated in this early 1900s image, excursion boats boasted a rather busy clientele. Here boats are lined up for customers, both coming and going.

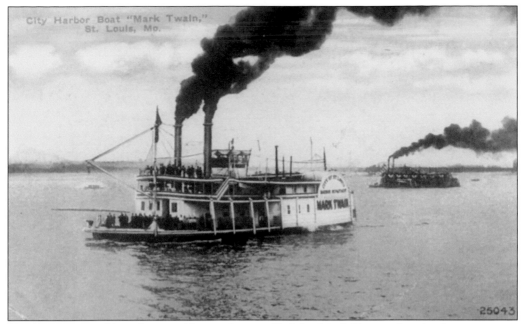

Here is a memorable sight: an old steamboat, called the *Mark Twain*, after the famous writer, serving as a harbor boat as it worked the St. Louis waters in 1908.

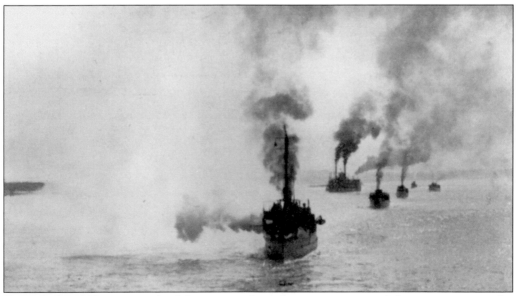

As part of a 1909 centennial celebration marking the incorporation of the town as a city, the United States Navy dispatched a flotilla of torpedo boats to honor the event.

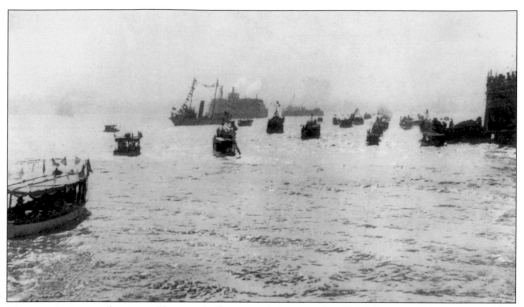

Here again is a gathering of boats of all sorts celebrating the 1909 Centennial occasion. This 1909 celebration was orchestrated by various business organizations to draw national attention to the city.

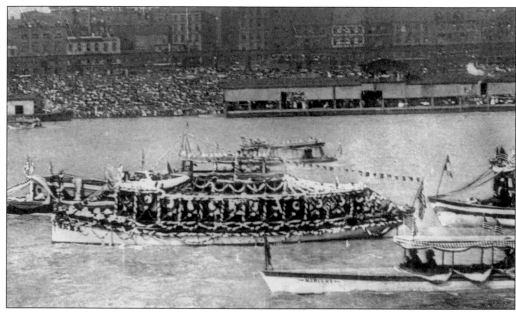

The highly decorated launch, pictured above, was the Veiled Prophet entry in the 1909 celebration. It was one of the prize winners in a contested river event. The Veiled Prophet event was St. Louis' most exclusive social affair for years.

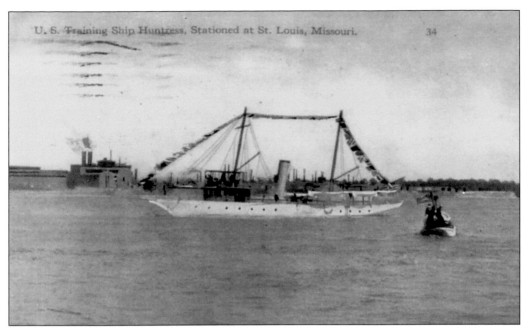

This Navy training vessel called *The Huntress* was stationed in St. Louis waters in 1913.

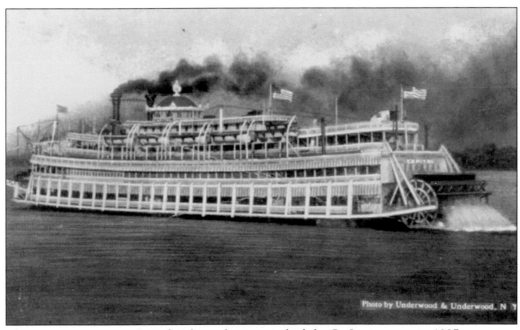

The excursion steamer *Capitol* is shown here as it plied the St. Louis waters in 1927.

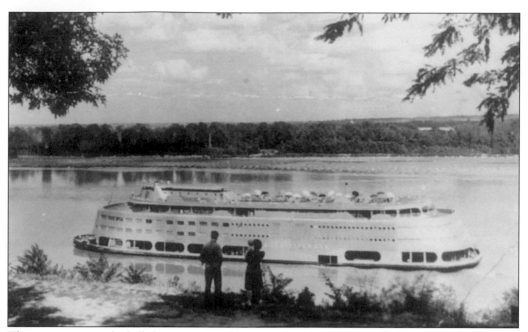

The most respected of all the excursions boats coming in and out of St. Louis was the *Admiral*, which has been dear to generations of St. Louisans. It is pictured here when it was at its most popular in the 1940s. It has recently returned to the city as a gambling casino.

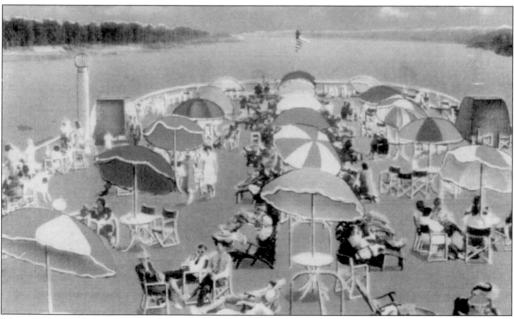

The *Admiral*'s elegant deck in the 1940s was filled with relaxing customers.

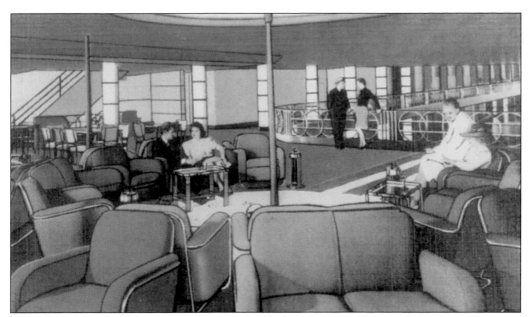

Another view of the luxurious *Admiral* in the 1940s: the Mezzanine Circle Lounge.

The Mississippi was not always so benign. In the flood of 1844, waters backed up against the warehouses on the landing. St. Louis, though once built on bluffs, soon found itself vulnerable when the town destroyed these bluffs.

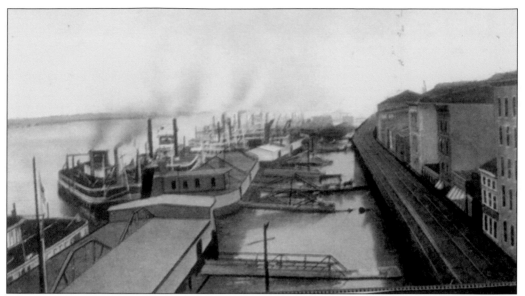

Before its vast floodwall was erected, St. Louis had to endure various serious floods. Here in this 1908 occurrence, we see another attempt to hold back the waters of the raging Mississippi.

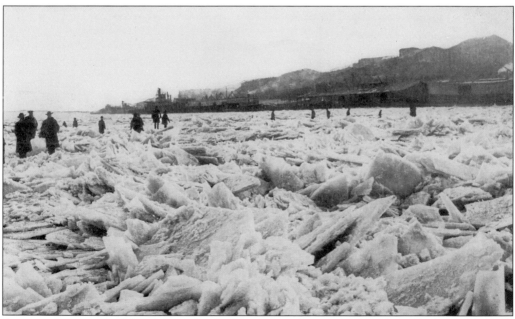

A rare event occurred here in 1907: the Mississippi froze over. People walked about on the extensive ice.

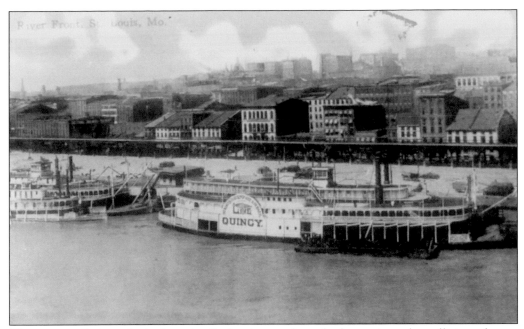

The steamer *Quincy*, docked on the St. Louis waterfront, had experienced a collision of some violence on July 11, 1906, when its hull hit a snag near a town in Wisconsin. All passengers fortunately were saved.

This handsome building at 10 N. Levee, a harbor house, was built in 1898. It later became the general office of the WPA during the Depression Era. The building was destroyed to make way for the Jefferson Expansion Memorial and the great St. Louis Arch. (Courtesy of NPS.)

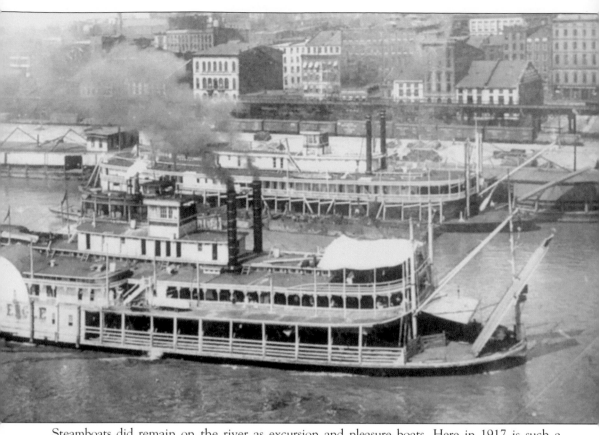

Steamboats did remain on the river as excursion and pleasure boats. Here in 1917 is such a carrier.

Three

EARLY COMMERCE

In this chapter we will deal principally with the existence of old St. Louis business structures, some of which were destroyed to make way for the creation of the famed St. Louis Arch and the park on which it stands.

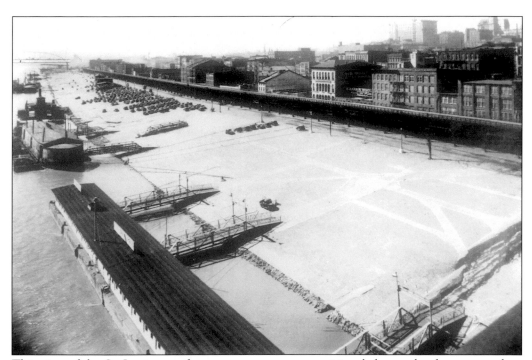

This view of the St. Louis waterfront captures a great transitional change that has occurred on the old traditional wharf. The cars parked in the far left indicate that the age of Ford has arrived in the city. (Courtesy of NPS.)

St. Louis, like all large cities, has faced many logistic problems as to how to route waste and sewage. After the devastating plague of 1849, city engineers built outlets on Washington Avenue that emptied into the Mississippi.

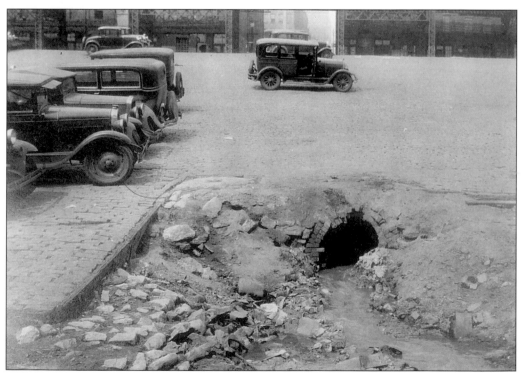

Still another sewage outlet into the river was this culvert erected in 1853. Although present-day ecologists would storm out with this arrangement, it was an improvement in its day. This film was created in the early 20th century. Notice the old autos shown here.

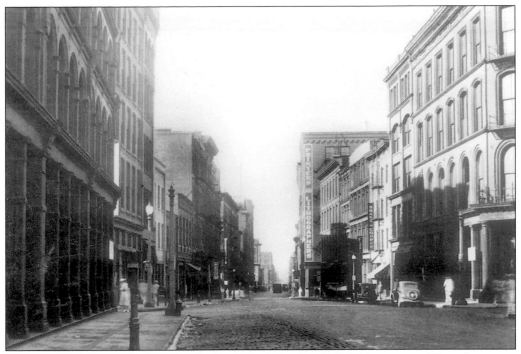

This is Third Street, looking south from Pine, in the early 20th century. This photo was probably taken by a member of the famed Piaget family of photographers. (Courtesy of NPS.)

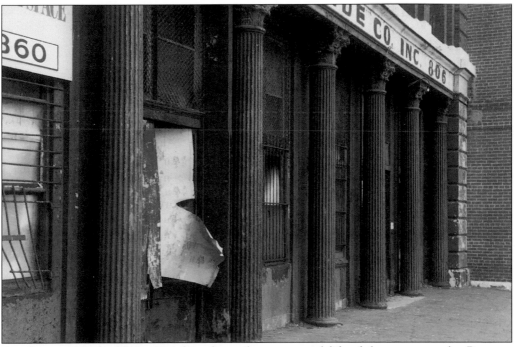

Another ancient building pivotal in the early commercial life of the town was the Bronson Hide Company, an important center in the prosperous fur trade of the day, *c.* 1840s–1850s. This building was demolished.

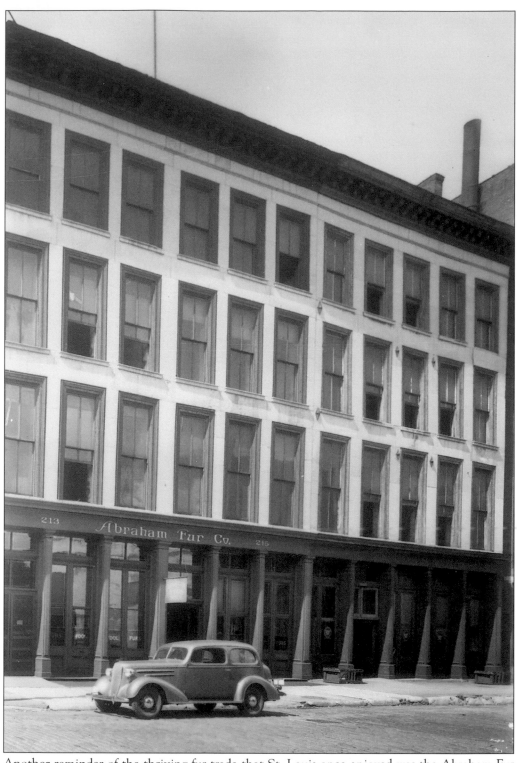

Another reminder of the thriving fur trade that St. Louis once enjoyed was the Abraham Fur Company at 213–215 First Street. This building was also torn down. (Courtesy of NPS.)

The most powerful member in the great fur trade district in downtown St. Louis was the F.C. Taylor Co., shown here in 1910. It was also demolished to make way for the Arch.

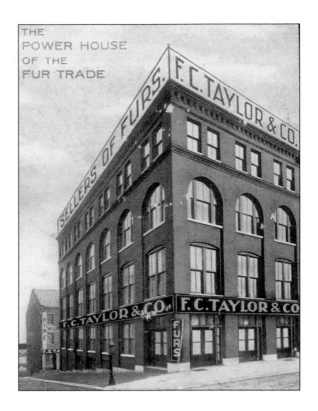

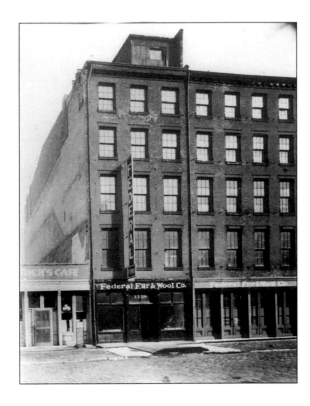

Another significant structure that suffered the fate of destruction was this one time prosperous building, the Federal Fur and Wool Co., built c. 1851. (Photo by Eugene Taylor, September 25, 1936. Courtesy of NPS.)

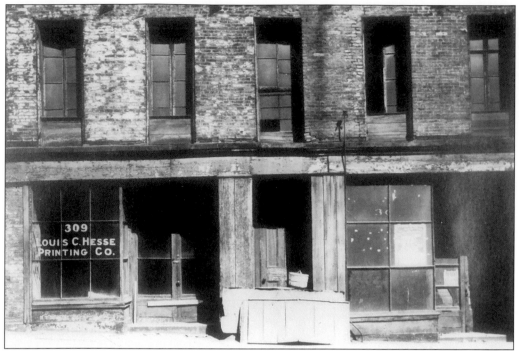

This once prosperous store, located at the lower portion of the Hall Building, graphically demonstrates the decline of St. Louis in the 1930s. Built before 1870, this building was also demolished. (Photo by Lester Jones, March 20, 1940. Courtesy of NPS.)

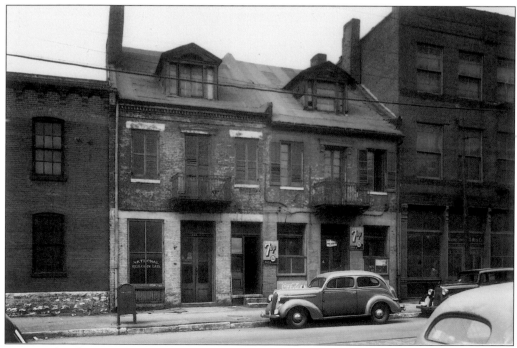

Among the distinguished early buildings gone to ruin was the so-called Fath House. The structure was erected by Jacob Fath as early as 1840–41. (Courtesy of NPS.)

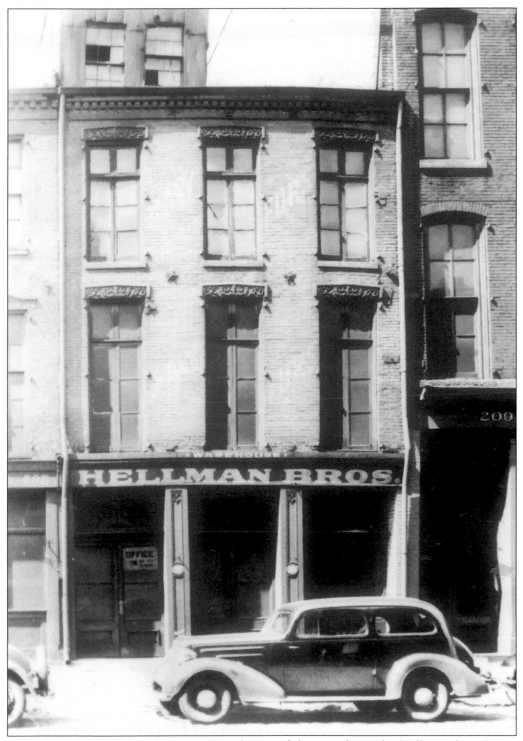

Built after the tragic fire of 1849, a typical store of the period was the Hellman shop. It was once the office of the historic Great Southern Overland Mail, a thriving mail service in 1858. It was also destroyed. (Courtesy of NPS.)

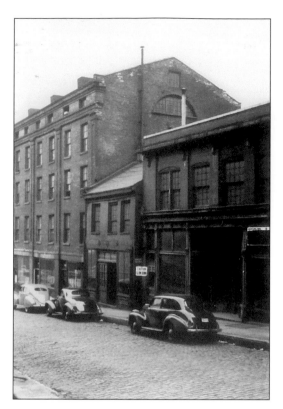

One of the famed great buildings of that period was the National Scott's Hotel. This building goes back to 1847 or earlier. It was also eliminated. (Courtesy of NPS.)

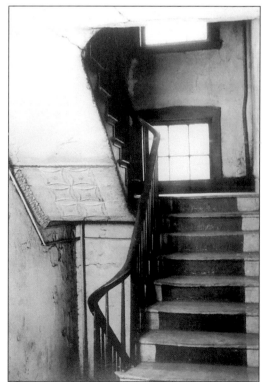

Here we see one of the elegant staircases, now in ruins, that once graced the famed hotel. (Courtesy of NPS.)

This photo was taken from the Johnson House at 613 Market before the demolition of the entire street. (Photo by Lester Jones, May 7, 1940. Courtesy of NPS.)

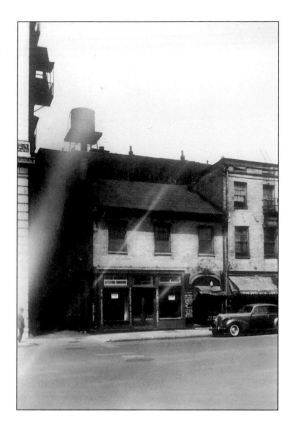

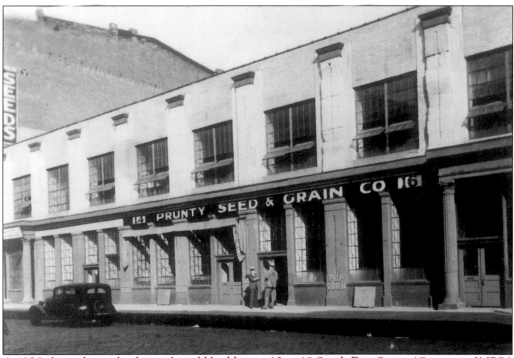

A 1936 photo shows the front of an old building at 10 to 18 South First Street. (Courtesy of NPS.)

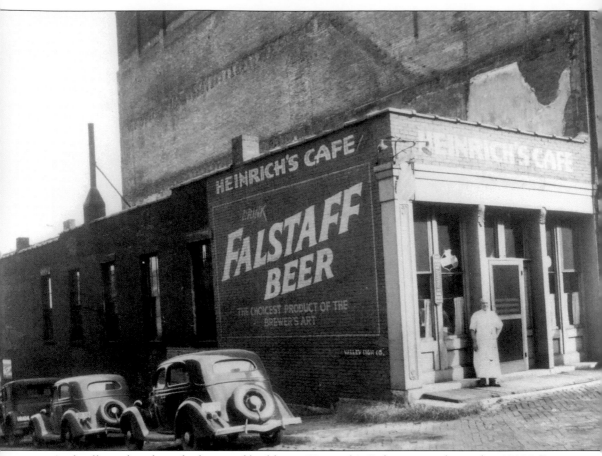

And still another shot of a destroyed building—Heinrich's Cafe was once located at 124 N. First Street. This picture was taken in 1936. (Courtesy of NPS.)

Four

THE JEFFERSON NATIONAL EXPANSION MEMORIAL

The most important symbol that identifies St. Louis to the rest of the nation, and for that matter to the world, is the monumental Gateway Arch. This enormous structure towers over the St. Louis waterfront and is visited by millions each year. Plans for the Arch began as early as the 1930s, when city officials began to demolish the area in preparation for the grounds for the Jefferson National Memorial Park. Several years later in 1948, famed Finnish sculptor Eero Saarinen won the design competition. Work was not completed until the 1960s.

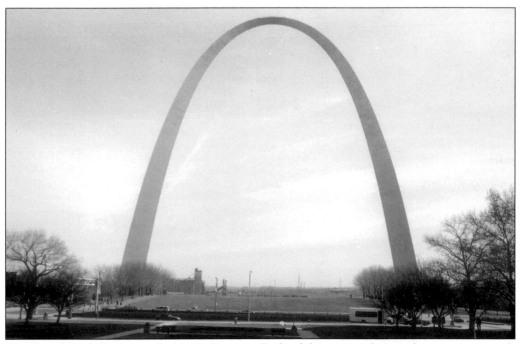

The famed Arch looms on the city's skyscape. Built of shinny stainless steel, it seems to reach towards heaven like the cathedrals of old. As an icon it appears to be both ethereal and practical—ethereal in the sense that it captures the promise of the West, pragmatic because it is an engineering marvel in its construction.

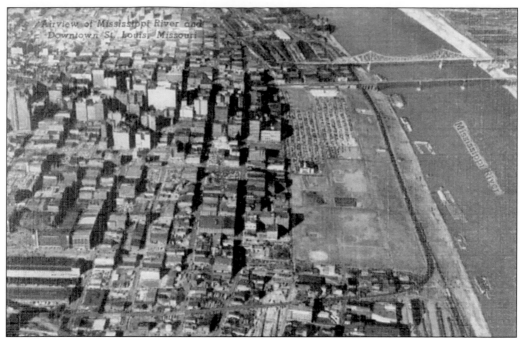

Seen here is vacant ground where St. Louis began its demolition for the Jefferson National Memorial Park. Most of the buildings we described, and many others, were on the doomed list.

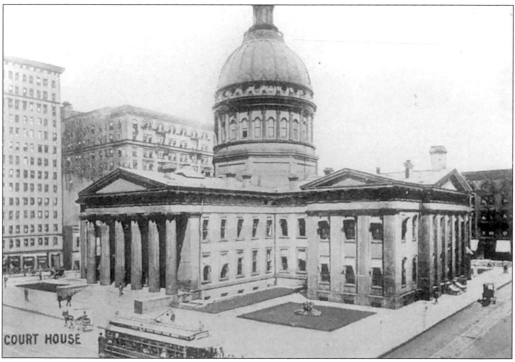

Of the original buildings that stood on the Jefferson Expansion grounds, two were of such historic value that they were preserved. The first of these is the old courthouse, famed for the Dred Scott case that was tried here. This photo, c. 1907–1908, captures the stateliness of the famous structure.

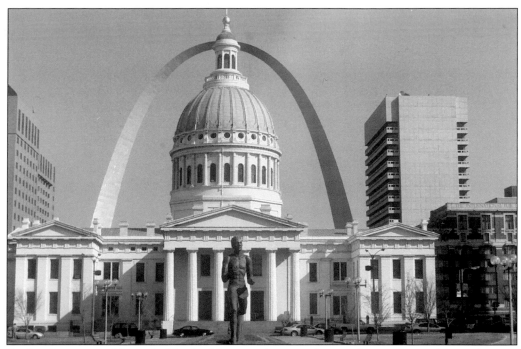

By far the most celebrated older building in the city, the stately courthouse has undergone various overhaulings. The present structure retains most of its 19th century features. Here we see it with the famous Arch in the background.

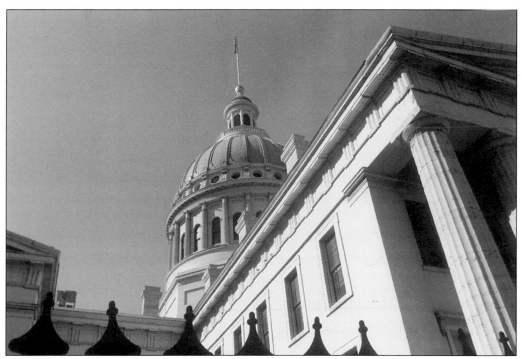

Seen here is another angle shot of the courthouse in which its Greek columns and Italian dome are captured in a sort of aesthetic contrast.

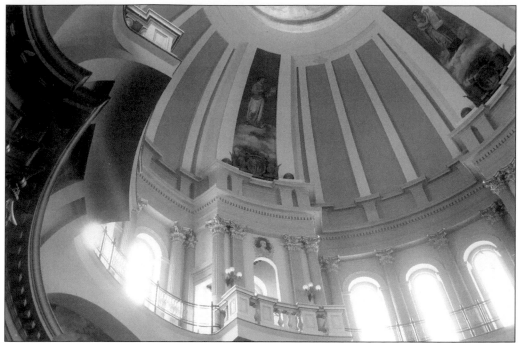

Seen here is another image of the courthouse whose beauty stands in strange relation to history. For it was here that the Dred Scott case occurred in which Scott, a slave, sued for his freedom, claiming that he had been a freedman in Illinois. He won his case, but on appeal the federal Supreme Court reversed the decision, declaring that Scott was a non-person. Here we see an image of its elegant staircase that climbs floor by floor to the top.

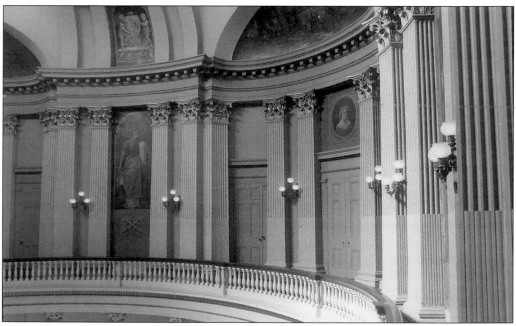

The arrangement of lights and classical columns provides the interior with a grace of both finesse and authority.

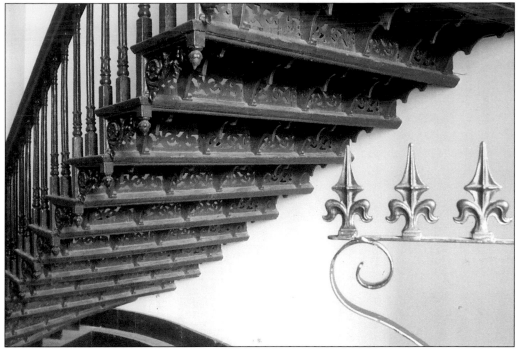

These stairs in the interior illustrate how detailed and graceful every small feature is in this handsome building.

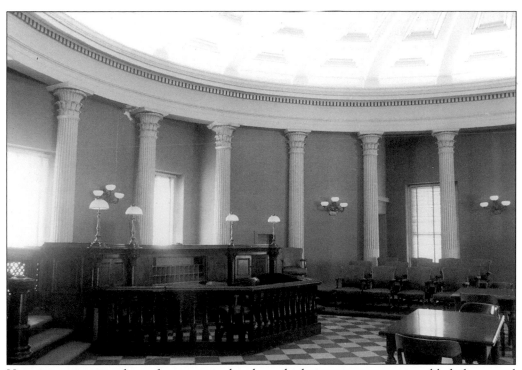

Here is an interior shot of a present chamber which in many ways resembled the actual courtroom where Scott was tried.

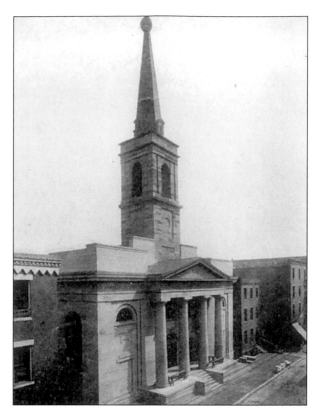

The second old building to survive the headache ball during the preparation for the Jefferson Expansion Memorial was the splendid old cathedral. Here is a card, postmarked from the post office on an Easton Avenue streetcar, which reveals an image of the old cathedral as it existed in 1909. Of Greek Revival design, this stately structure with its tall, pointed tower remained intact though fire, flood, cholera, and the park expansion. It remains on the park grounds, unreconstructed, and is one of the oldest buildings left in the city.

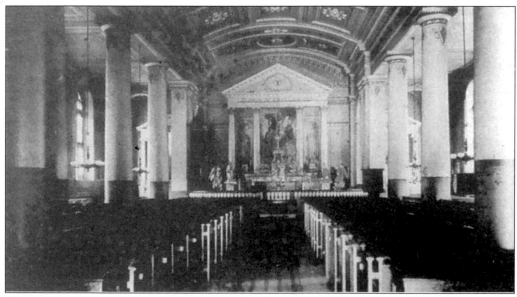

This photo shows an early interior shot of the old cathedral photographed in 1882.

Five

HISTORIC CHURCHES

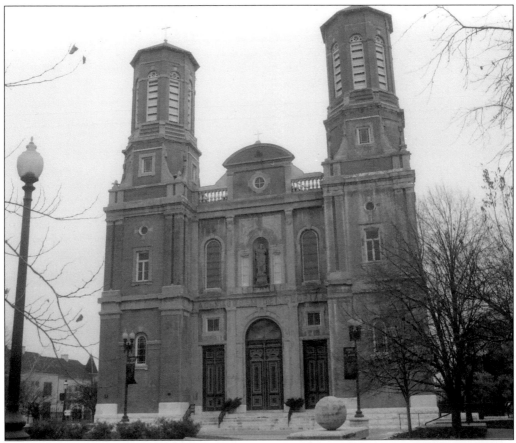

One of the better known of all the downtown churches is St Joseph's Shrine at 1220 N. Eleventh Street. Known as the "church of miracles," it was thought by some to be the source of miraculous cures. It was once run by the Jesuits, but is now served by the Capuchin order.

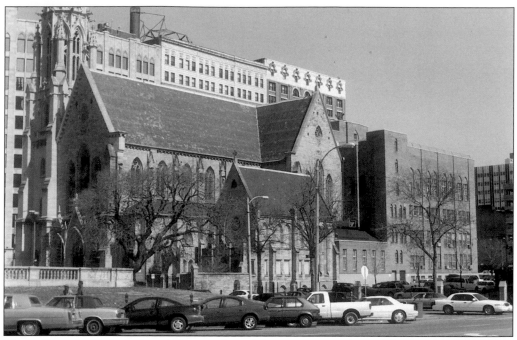

Christ Church Cathedral, at Thirteenth and Locust, is seen here. The principal house of worship of the Episcopal faith is this handsome English structure in downtown St Louis. It was completed after sundry starts in 1876.

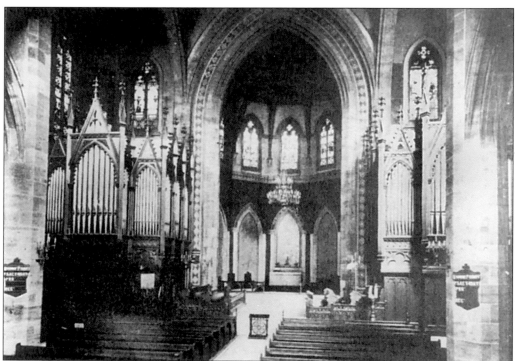

This 100-year-old photograph of the cathedral displays the breadth and scope of its vast interior, moving from its row of pews to the main apse and altar.

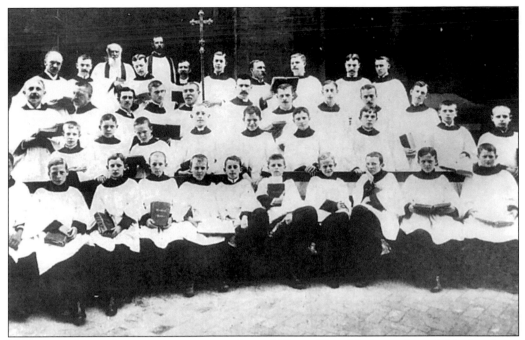

Here, in a photo of yesteryear, is a group shot of Christ Church's devoted youthful altar boys. Some are holding the sacred books of the service.

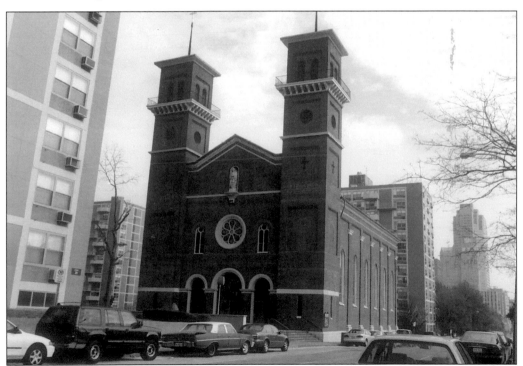

St. John the Apostle and Evangelist Roman Catholic Church is one of the various Catholic churches in the downtown area. St. John the Apostle exists in a complex of high-rise apartment houses known as Plaza Square.

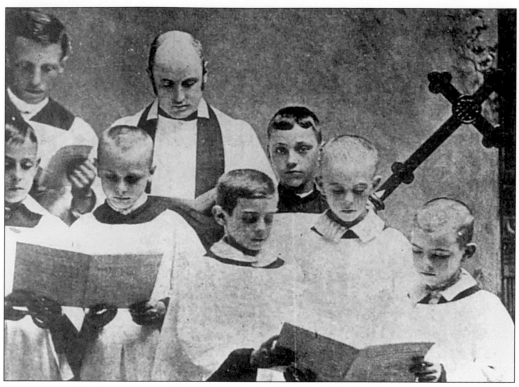

This early photograph captures the grace and innocence of these young members of the choir at St. Johns in a 1900 group gathering. Here they seem about to perform at a church service.

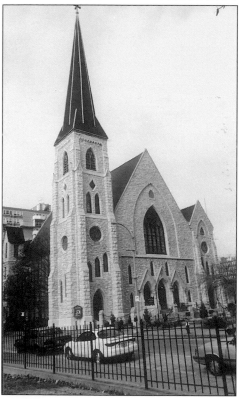

Another handsome structure in the downtown is the Centenary United Methodist Church at Sixteenth and Olive Streets.

The Irish Catholic Church in downtown St. Louis is St. Bridget of Erin at 2401 Carr Street. Old Catholic cemeteries in the downtown area were found obtrusive. Years ago, the bodies of the faithful were reburied under church property.

An additional Catholic church in the downtown area is St. Stanislaus, at 1413 N. Twentieth Street. This church was erected by the Polish community that once surrounded the church. Mass here is performed in Polish as well as in English.

Six

PUBLIC BUILDINGS

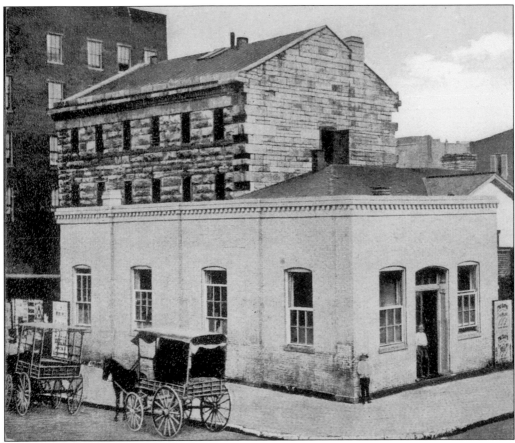

With all its pristine starkness, on this corner stood the St. Louis City Jail (1820–1871). This 1907 photo of the old building shows how criminal surveillance was then conducted by horse and buggy.

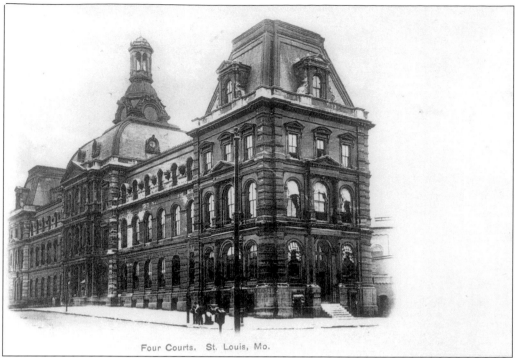

Four Courts. St. Louis, Mo.

Four Courts, St. Louis' legal complex, is seen here in 1906. It was erected on the former site of the Henri Chouteau mansion. The first important courthouse of the city, it was demolished in 1907.

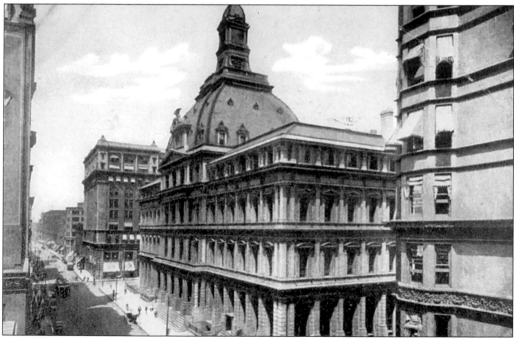

Pictured here is the post office in 1909. Once the thriving center of postal service, it suffered a great decline in the 1930s. Much controversy ensued about whether to tear down the handsome building with its excellent pine deco lamps and its nine fresco murals. Recently, however, it was renovated.

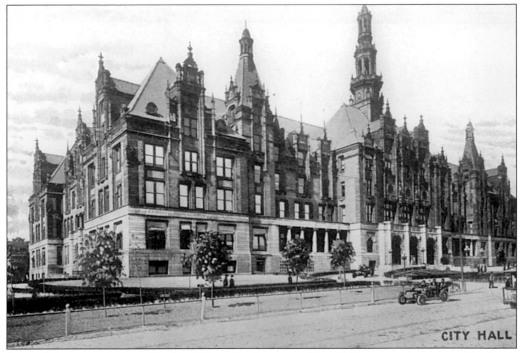

One of the most distinguished buildings in the town, City Hall appeared on many St. Louis promotional postcards. Here is an early one of this French renaissance building displaying the green lawns that once surrounded it.

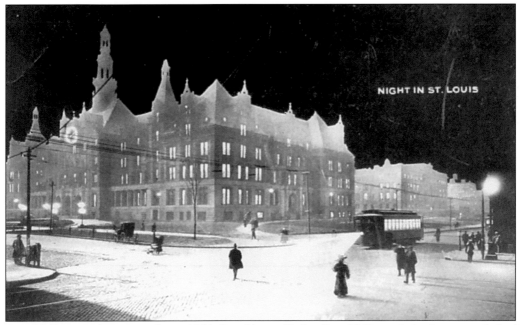

City Hall is seen here at night in 1919. In a blaze of light, City Hall stands forth as a symbol of the authority and grace of the city.

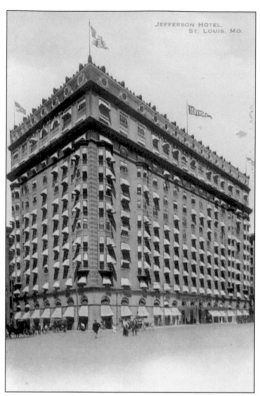

The famous Jefferson Hotel is pictured here in a 1910–1912 photo. The Jefferson was one of the grand hotels of its times, housing such celebrities as Harry Truman and other visiting notables.

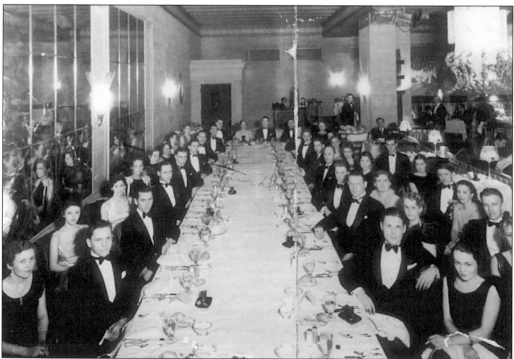

The Jefferson Hotel is pictured here, c. 1934. This interior shot of a formal event being held at the hotel suggests the elite quality of most of its clientele.

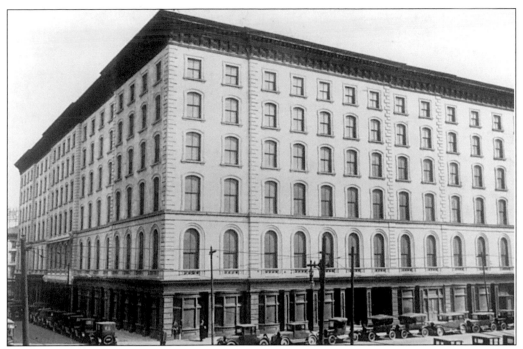

Another famed hotel of the 1920s was the Southern Hotel. Notice the automobiles lining the walks beside it. With not a horse and buggy to be found, the photo reveals the great transformation that has occurred in the city's traffic.

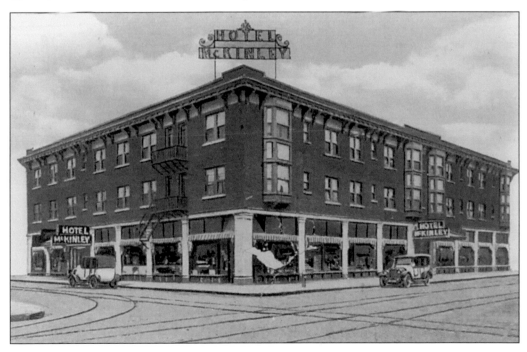

Hotel McKinley is seen here in the late 1910s, at Twelfth Boulevard and Morgan. It was named after the McKinley who owned the Illinois Terminal Railroad, instead of President McKinley.

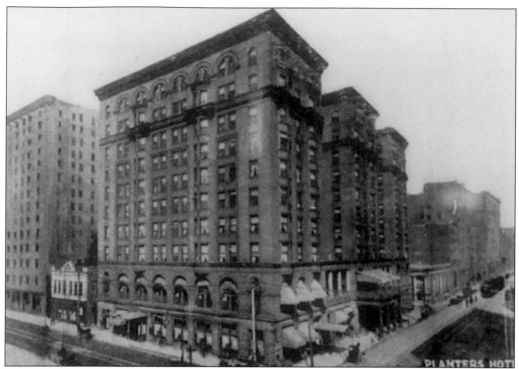

The king of all the hotels in the city was the Planters Hotel. Here notable guests such as Charles Dickens and James Audubon once stayed. The hotel stands out historically since a conference held here in 1861 helped to foment civil war in Missouri.

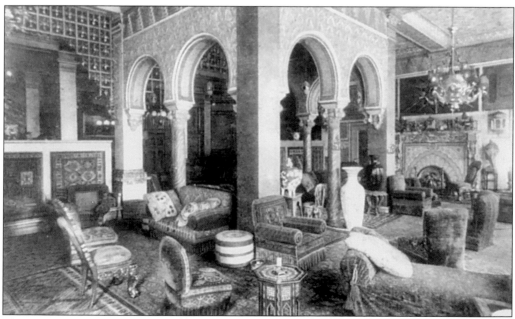

This interior shot of the Planters Hotel demonstrates the opulence and luxury of its furnishings. Popular in its time was the Turkish corner, decorated in the motifs and emblems of the Middle East. Here is the hotel's Turkish Den.

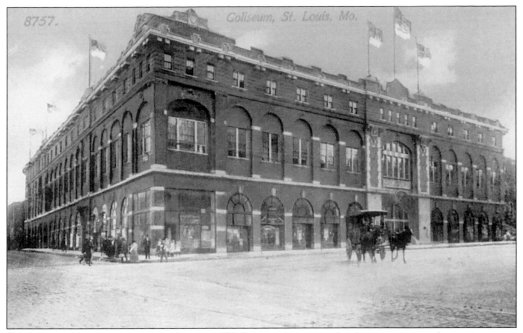

St. Louis once boasted a sports arena called the Coliseum, which was a venue for major sport events of the day. It was similar to New York's Madison Square Garden. Painted into this 1909–1910 picture were American flags.

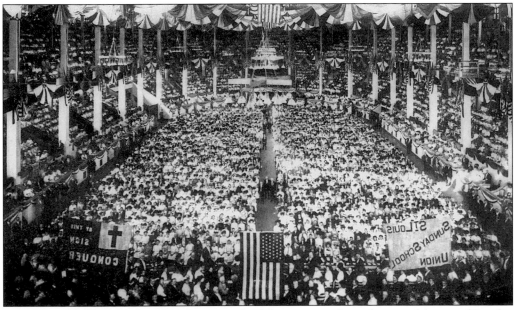

A feature of the spectacular 1909 Centennial celebration was the gathering of dozens of Sunday Schools in convocation at St. Louis' sport palace, the Coliseum.

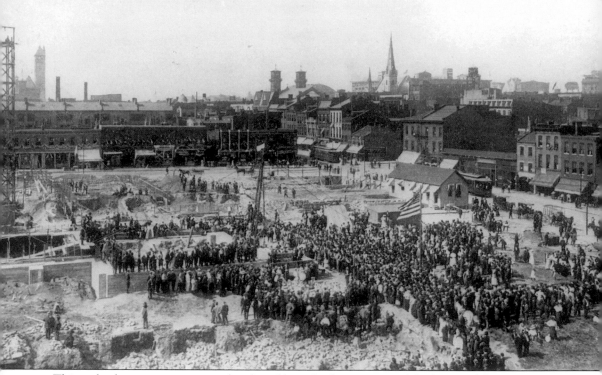

This early photo captures a crowd gathered here for the occasion of the laying of the cornerstone of the new municipal courts.

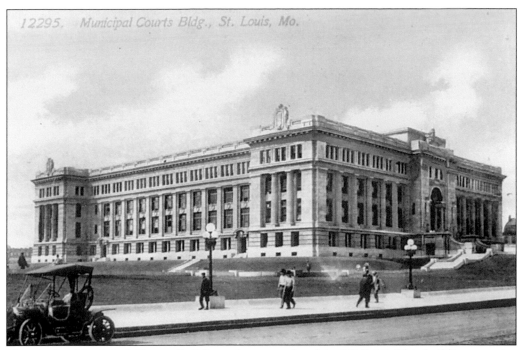

Here is the Municipal Courts Building when completed in 1915–16. This building remains unchanged to the present day.

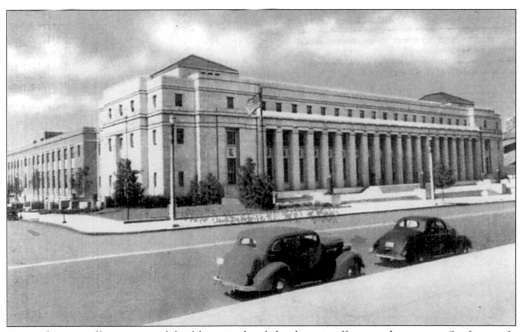

An architecturally renowned building is the federal post office in downtown St. Louis. It gracefully combines art deco and classical features. in an eclectic fashion Springs in the grounds made it difficult to build in the 1930s. The springs still flow, but into the sewer system.

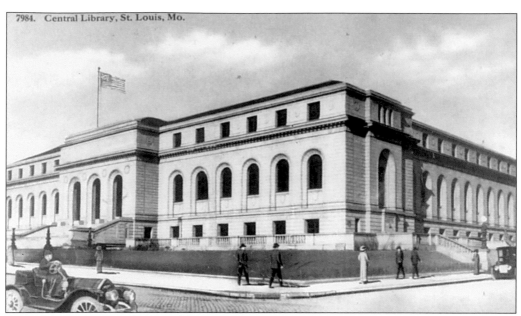

One of the architectural gems of downtown St. Louis is the Central Library, seen here in 1910. This handsome arched structure now contains an enormous collection of books, tapes, and archival material.

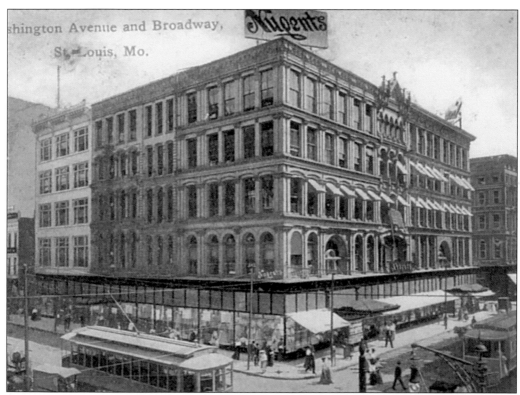

Here is another of the various business places in downtown St. Louis. Nugent's Department Store is pictured in 1912.

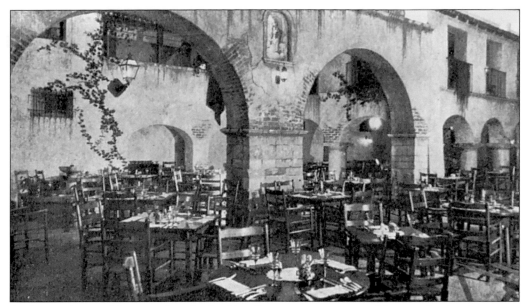

As the caption on this postcard reads, the Castella restaurant was one of the most fascinating supper clubs in the city. It was located in the first half of the 20th century on Washington Avenue.

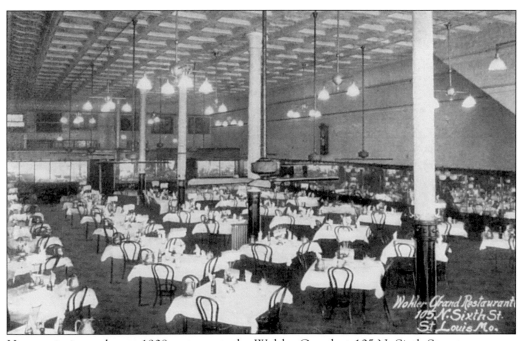

Here again is an elegant 1908 restaurant, the Wohler-Grand, at 105 N. Sixth Street.

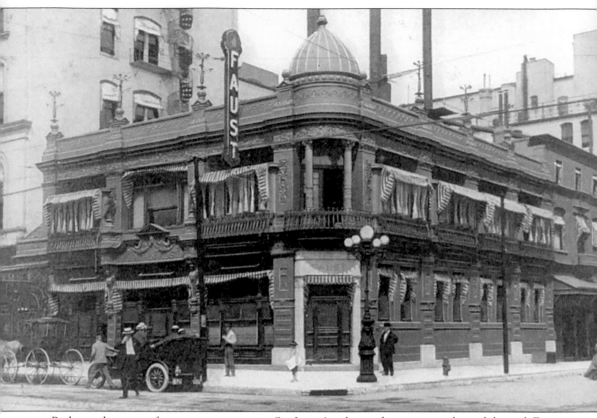

Perhaps the most famous restaurant in St. Louis' culinary history was the celebrated Faust restaurant whose clientele were the economic elite of the city. It was often compared to the best restaurants in the country. (Photo, 1910.)

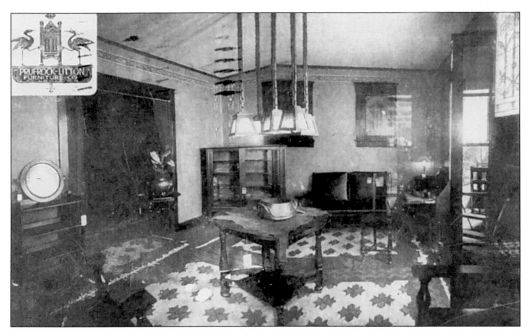

Perhaps the most famous of all St. Louis' downtown businesses that have long ago disappeared is the Prufrock Litton Furniture Co., seen here in 1910. The Prufrock name was universalized by world-famous T.S. Eliot in his celebrated poem *The Love Song of J. Alfred Prufrock*.

This photo of this lovely young lady was taken early in the last century in a studio on Franklin Ave. It was one of the many photo studios that existed downtown during this time.

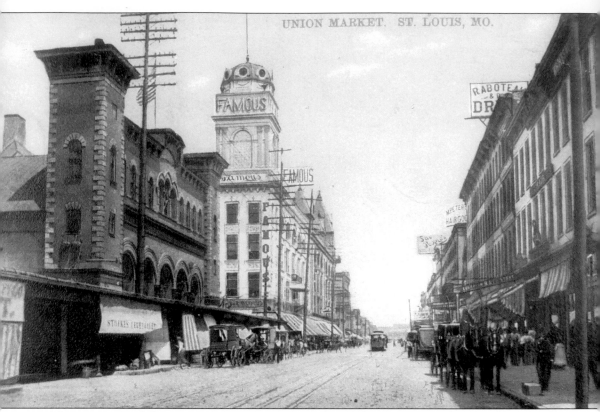

This is a view of downtown St. Louis' most popular market, Union Market, (building to the left) as it appeared in 1907. It is now the site of a Drury Inn, one of a series of hotels created in the city by one of its most devoted citizens, William Drury.

Seven

SCHOOLS

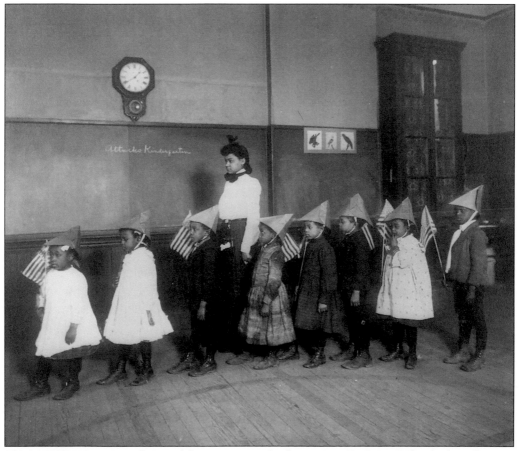

The miniature pageant depicted here at an early downtown St. Louis school, Attucks, was called *Little Soldier Man*. It was an exercise conducted by the school's kindergarten, c. 1900.

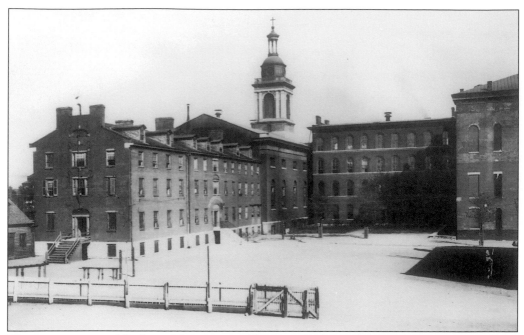

This interior view of St. Louis University's old campus looks northeast. The original university building is on the left with an arch over the doorway. St. Francis Xavier church and other buildings are seen from behind.

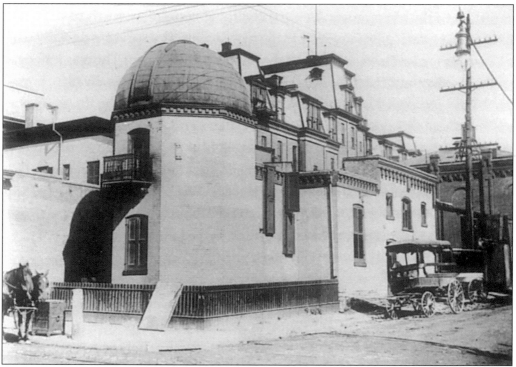

Washington University's Observatory was constructed in 1878. Despite the smallness of this building, the observatory in its day was one of the busiest in the nation.

Washington University's Football Team (1899–91) is seen here. Collegiate competition was introduced in 1890 after years of intramural sports only.

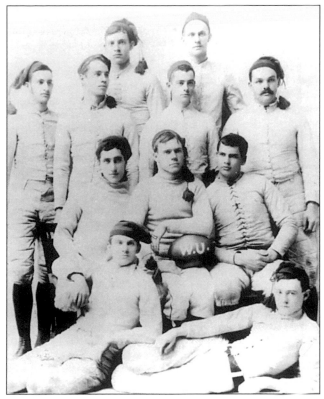

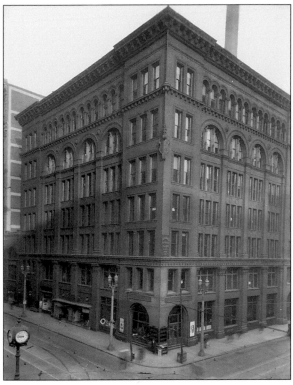

St. Louis Board of Education Administration Building was located at 911 Locust in January 1931.

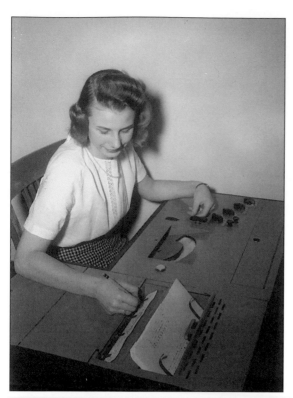

At this building on Locust, the administrative office of the St. Louis Public Schools, a teacher is shown grading exam papers with a special device, c. 1947.

Kindergarten little folk from Madison School form a holiday ring around an enormous Christmas tree on December 1932, at the Instruction Department Office.

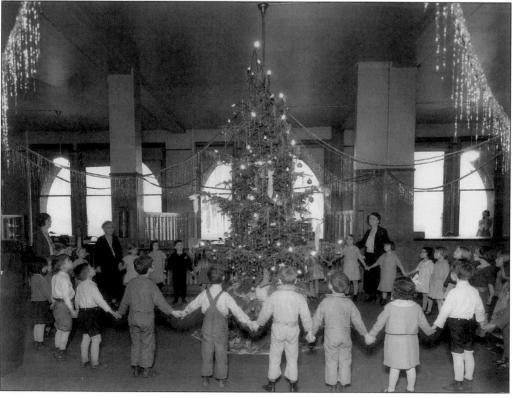

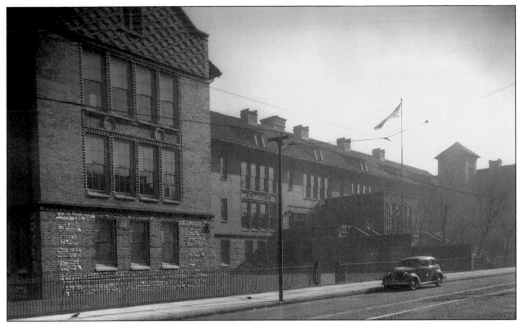

Pictured here is another school in the downtown St Louis area: the Henry School, located at 1220 N. Tenth Street in November 1938.

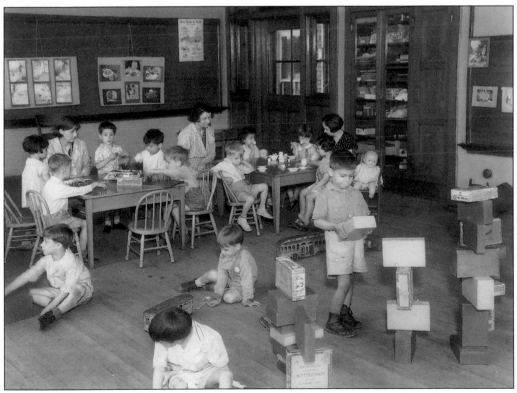

Here is a glimpse of the Henry School pre-school toddlers as they enjoy "Such Happy Times." (May 1934.)

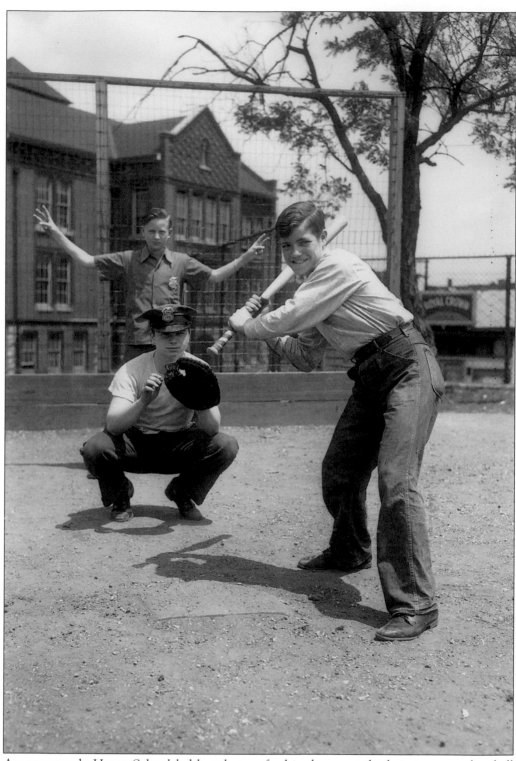

An upper-grade Henry School lad hunches up for his chance at the bat at a recess baseball game in May 1946.

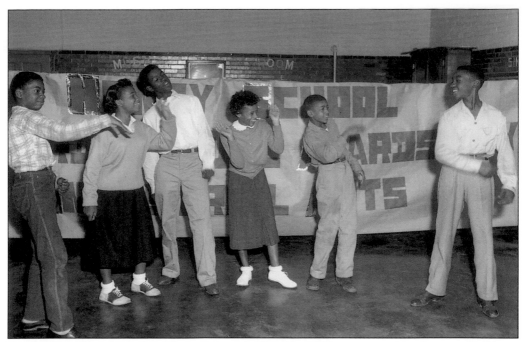

Pictured is a drama group at Henry School in October 1955.

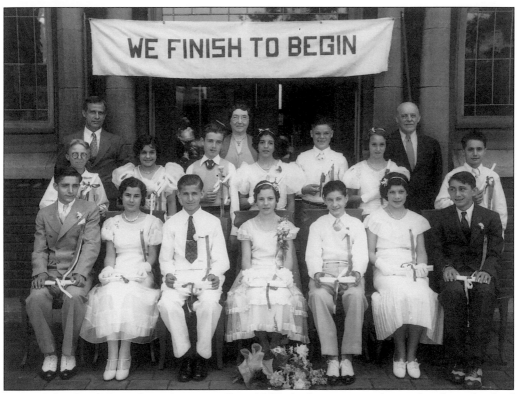

WE FINISH TO BEGIN

Henry School eighth grade graduation in June 1933. As their sign proclaims, they have finished one stage of their career and are entering a new one.

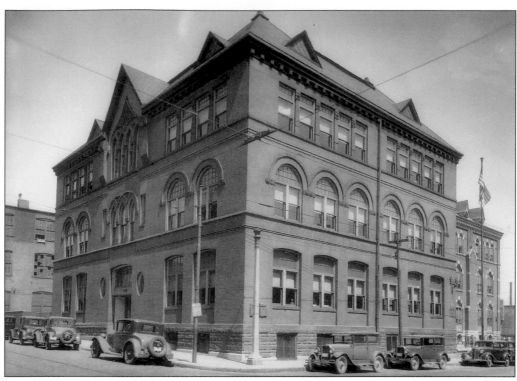

The handsome Jefferson School at 903 Cole was flanked by cars of all sorts in June 1936.

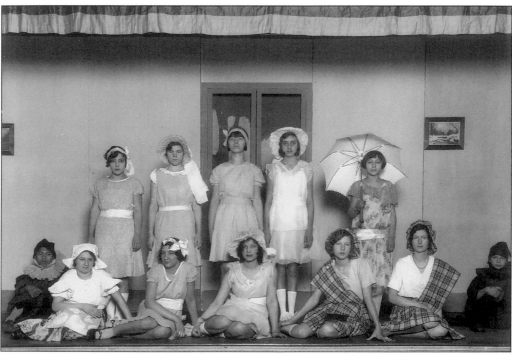

Here are students of the Franklin School, located at 814 N. Nineteenth Street, in another episode from their December 1930 Christmas Program, *In Santa's Toyshop*.

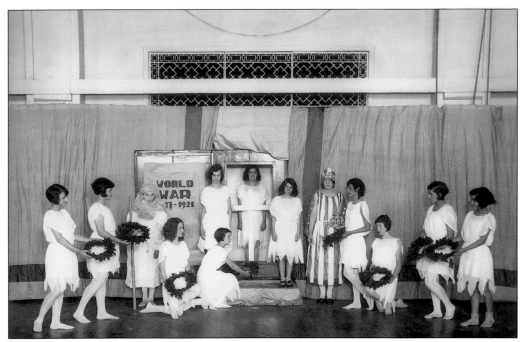

Among the many academic events presented at Franklin School in the 1930s was this Memorial Day pageant—*In Flanders Fields*.

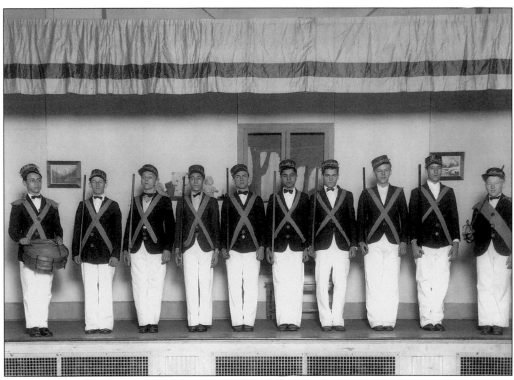

Franklin School's Christmas celebration included the play *In Santa's Toyshop*, in which various students appeared as tin soldiers. It was held in December 1930.

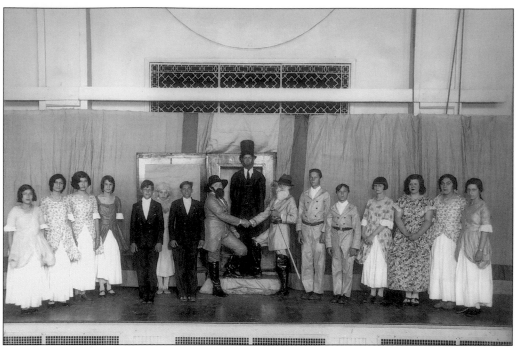

Another Franklin School event was a Memorial Day pageant called *Civil War Soldiers, 1861–65*. It was performed in June 1930.

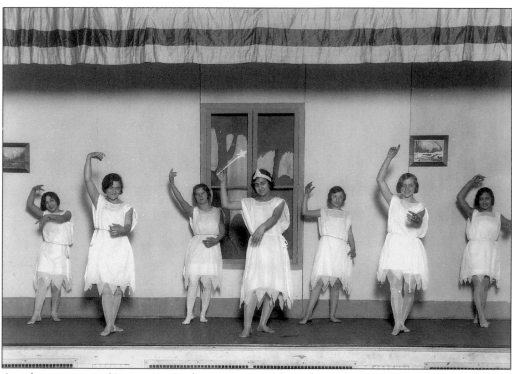

Another segment of *In Santa's Toyshop* at the Franklin School in December 1930. Some of the young women performed as fairies.

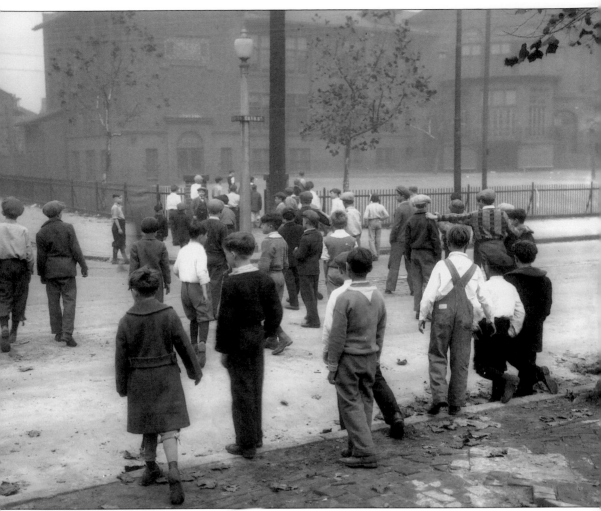

Here in October 1929, is a glimpse of the unorganized student traffic at Carr School before patrol boys were used to protect students crossing the street.

The elaborate designs on the exterior of Carr School, created by the master architect William B. Ittner, illustrate with what artistry many of these early school buildings were constructed. Now it is crumbling into dust.

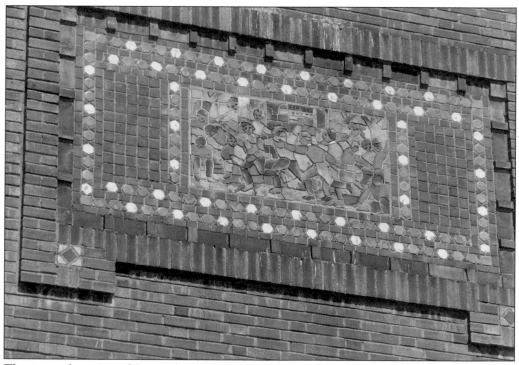

This is another view of Carr School's decorative mosaic.

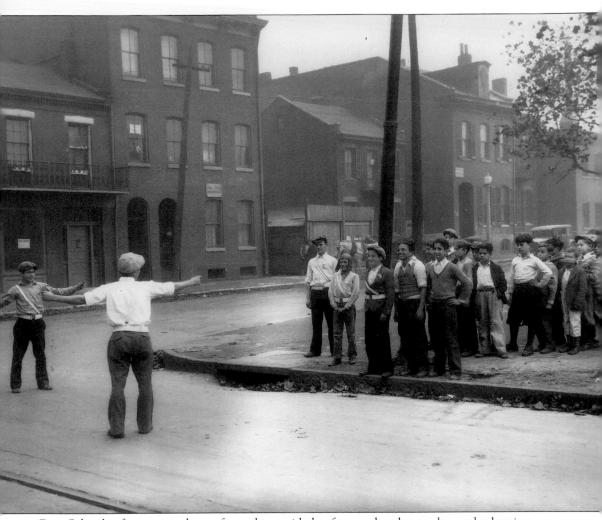

Carr School, after a patrol was formed, provided safety and order to the ranks leaving or entering the school.

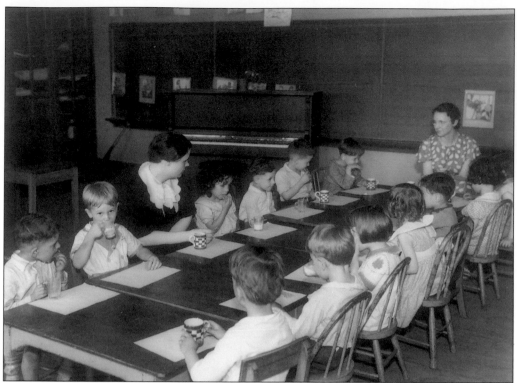

Students are enjoying their morning lunch at a Carr School pre-school class in May 1934.

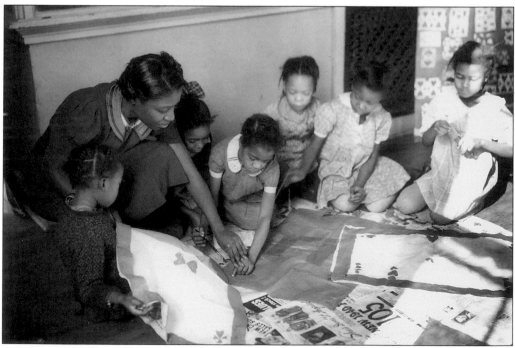

Another activity involving young hands during a Valentine Day project at Carr School in February 1940.

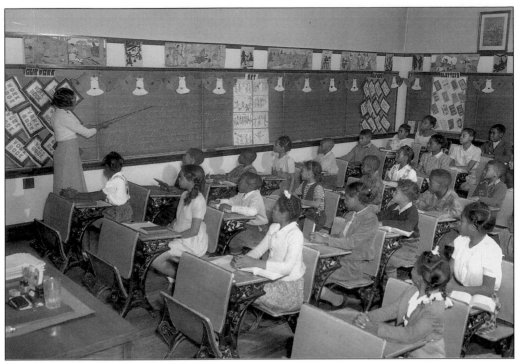

Carr School in December 1945, as students listen eagerly to their instructor.

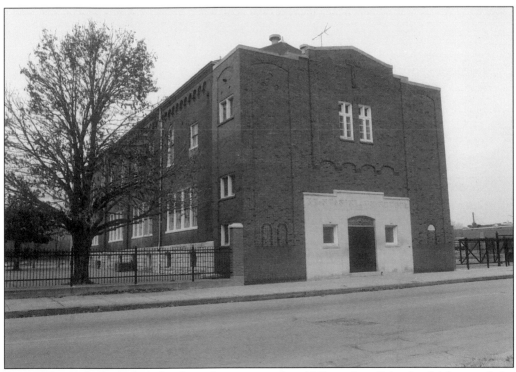

One of the early Catholic schools in the city was the old Stanislaus School, which served the children in a neighborhood downtown.

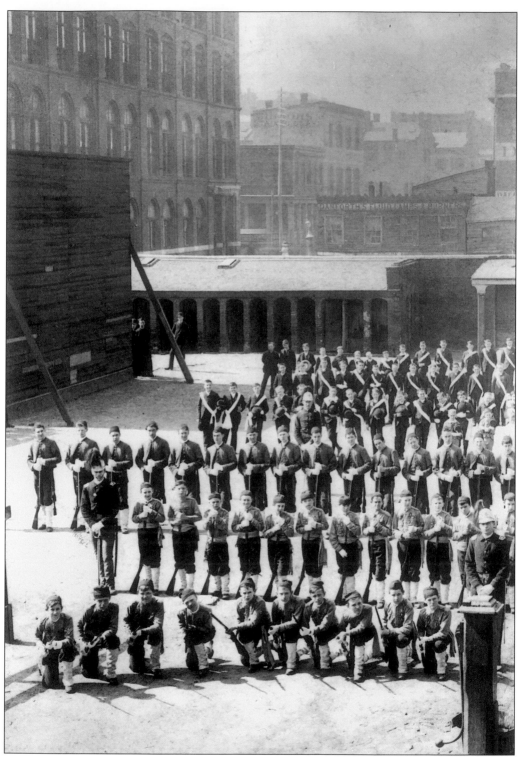

In the late 19th century, St. Louis University Junior Cadet Corps gathered on the old campus at Ninth and Washington.

Eight

DOWNTOWN LIFE

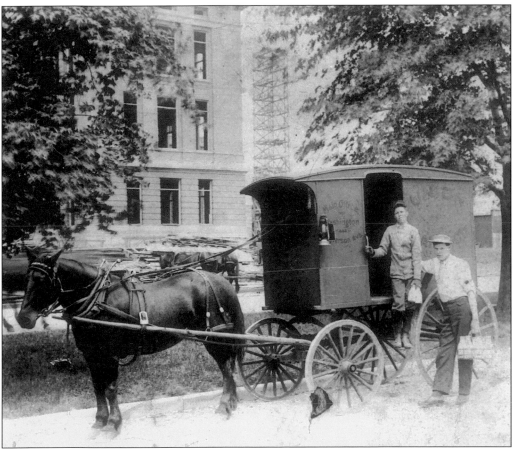

Here is a turn-of-the-century milkman with his assistant as they prepare to deliver milk to the downtown area. Equipped with his horse and buggy and his glass bottles of milk, he seems ready to start his day.

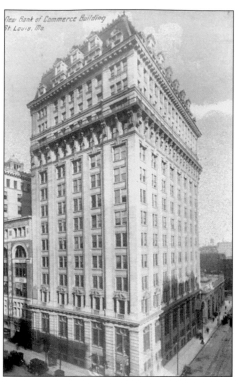

As the postcard caption indicates, this admirable building is the New Bank of Commerce, pictured here in the 1910s. The building seems to mix a sense of beauty with one of authority.

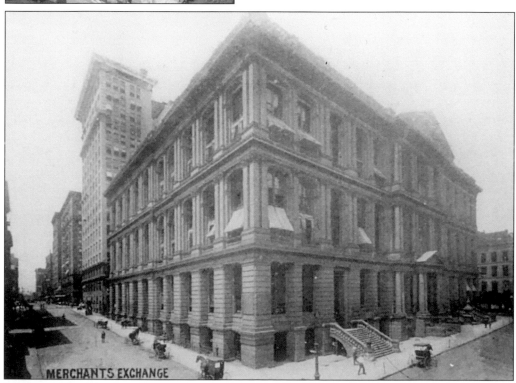

The handsome Merchant Exchange Building was removed in March 1958, to make way first for a parking lot, and finally as part of the site of the new Adams Mark Hotel.

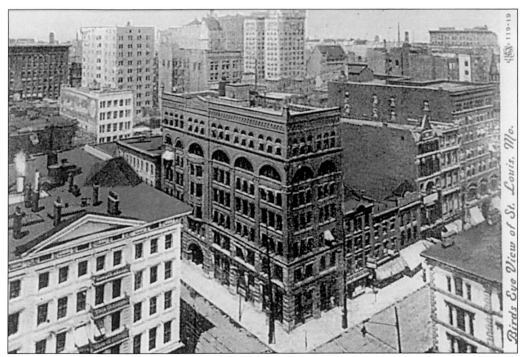

Here is a scene which a postcard describes as a "bird's eye view" of downtown 1907 St. Louis.

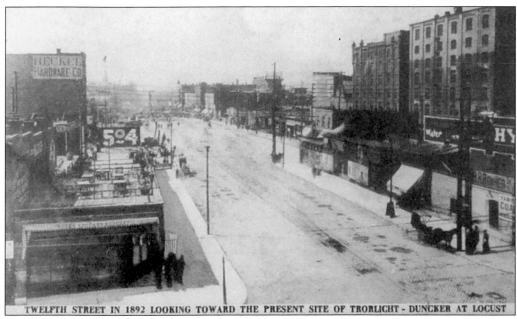

TWELFTH STREET IN 1892 LOOKING TOWARD THE PRESENT SITE OF TRORLICHT - DUNCKER AT LOCUST

Here is an outstanding shot for a postcard that depicts a street scene of Twelfth Street in 1892.

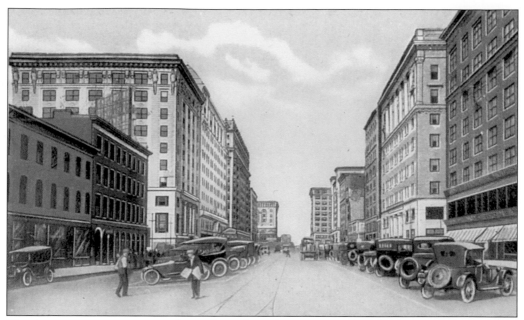

Here is a street scene to remember: a line of standing motor cars as they are parked downtown in the l920s on Twelfth Street, north from Pine.

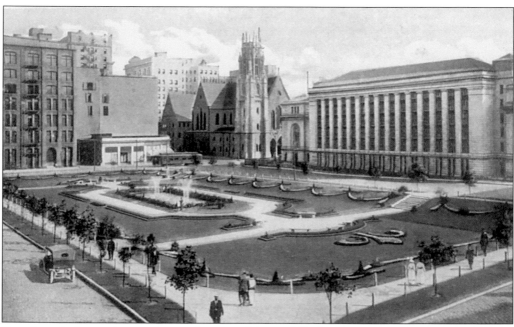

Seen here is the sunken garden in the rear of the artfully designed public library in the 1920s. The garden once acted as a park on the private grounds of the genteel Lucas Place.

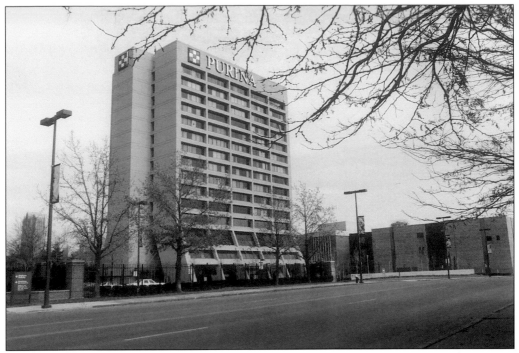

The famed Checkerboard Square, national headquarters of the Ralston-Purina Co., long a city stalwart, was sold recently to a gigantic global combine.

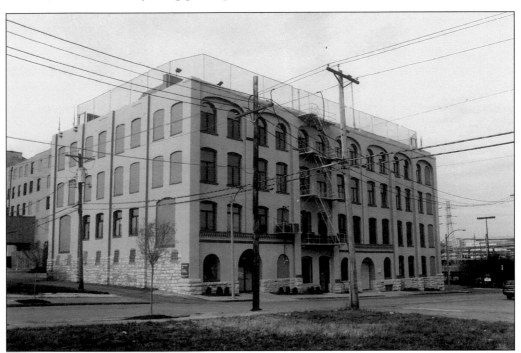

A view of a 1800s warehouse, located at Chouteau and Eighteenth, was recently renovated by Ralston-Purina. This building has been skillfully revamped to house an elegant upstairs penthouse that overlooks most of downtown St. Louis.

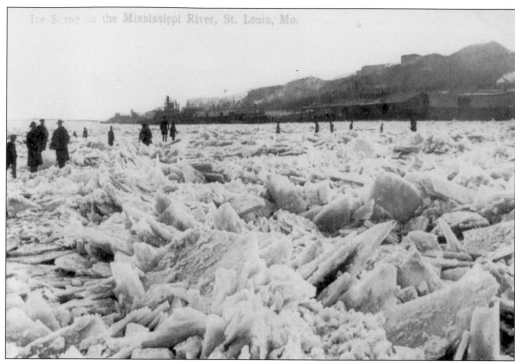

Ice Scene on the Mississippi River, St. Louis, Mo.

An ensemble shot: Jefferson Hotel, the curved Shell Building, and the public library, all remarkably well preserved.

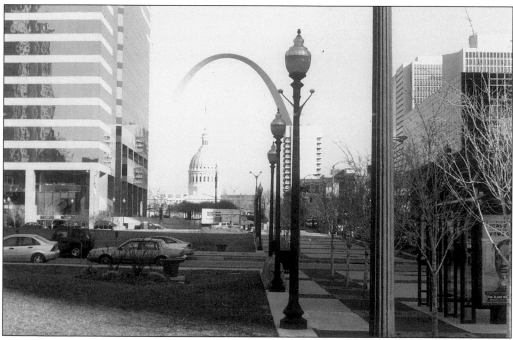

Pictured here is Market Street looking east. In order to provide this open expanse that ends with the celebrated courthouse, several important buildings were demolished. "The old order collapses, giving way to the new."

Another significant downtown building was the imposing Missouri Pacific Building, shown here in 1915. It later became known as the Buder Building. It was torn down in the early 1980s with two other historic structures to make way for the Gateway Mall.

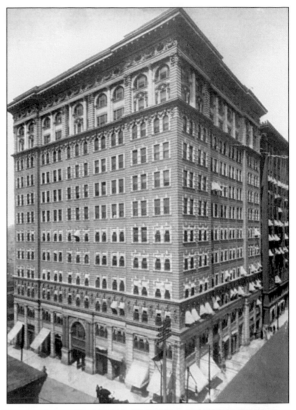

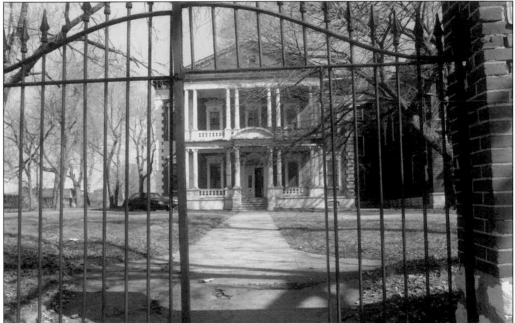

This dignified structure, the James Clemens Jr. house at 1849 Cass Avenue, is noted not only for its architectural grace, but for its name. Called the Clemens house after a close relative of Mark Twain, it has remained intact through some difficult times.

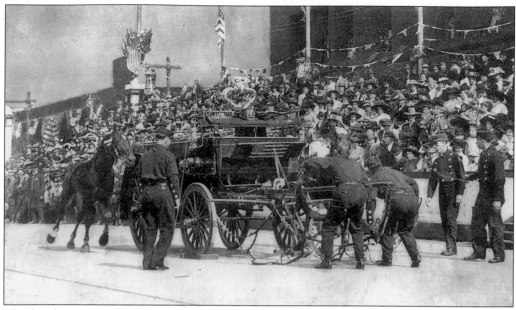

The fire department drill was a feature of one of the parades of the 1909 Centennial.

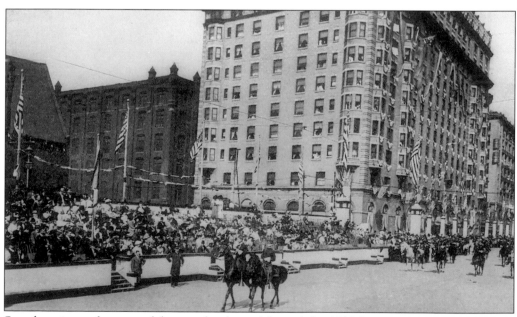

Seen here is another one of the parades that celebrated the 1909 festivities.

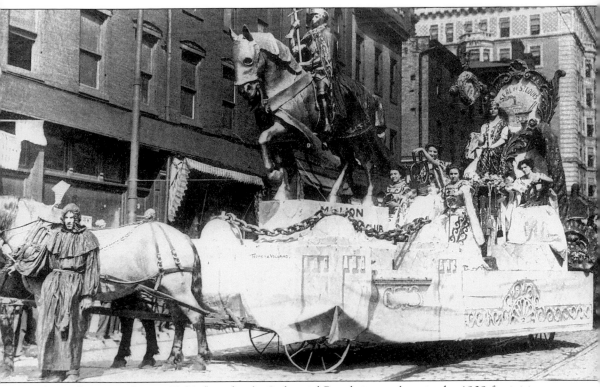

The Million Population Club's float for the Industrial Parade is seen here in the 1909 festivities.

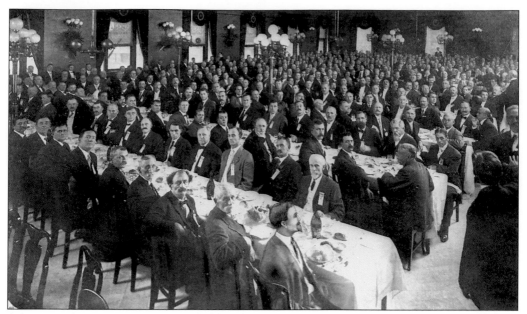

A banquet for visiting mayors was held at the Jefferson Hotel as part of the 1909 events.

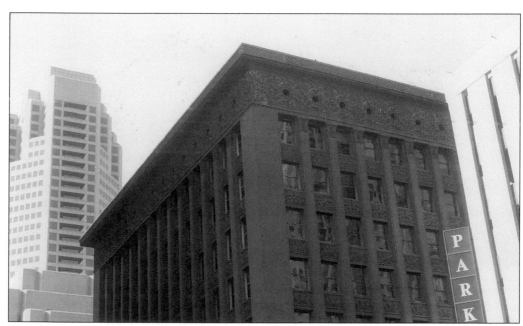

The Wainwright building, designed by the famous architect Louis Sullivan in 1901, was one of the first skyscrapers made with iron. It stands near to the imposing and modern Federal Courthouse. It is one of the greatly admired architectural treasures of St. Louis.

This building, shown here in 1908 as the Victorian Building, later became the St. Nicholas Hotel.

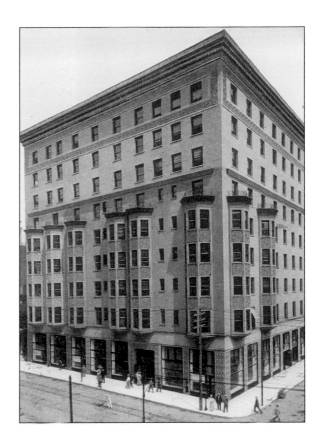

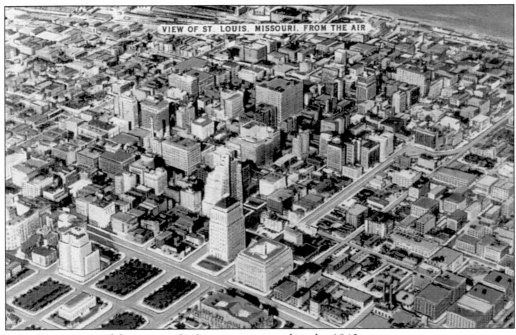

A bird's-eye view of downtown St. Louis as it existed in the 1940s.

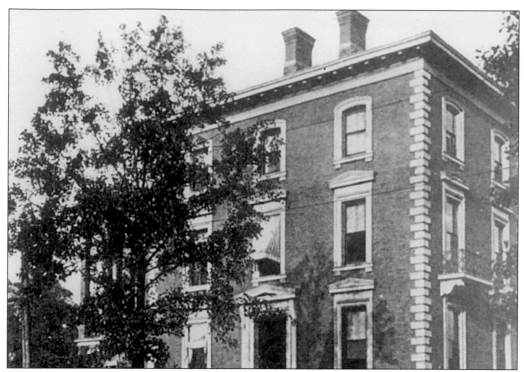

Henry Shaw's townhouse was located at Seventh and Locust. His creation of a vast botanical enclosure provided St. Louis with a majestic public garden, seldom equaled in the modern world.

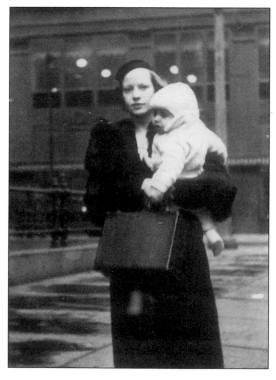

St. Louis Portrait—mother and child, this time in the Depression 1930s, as they appear downtown, probably on a shopping tour.

The Cass Avenue Streetcar pictured at the turn of the century.

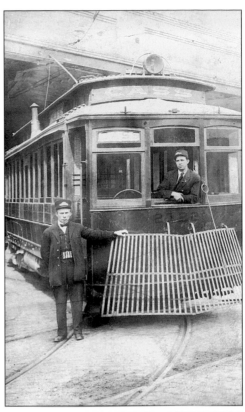

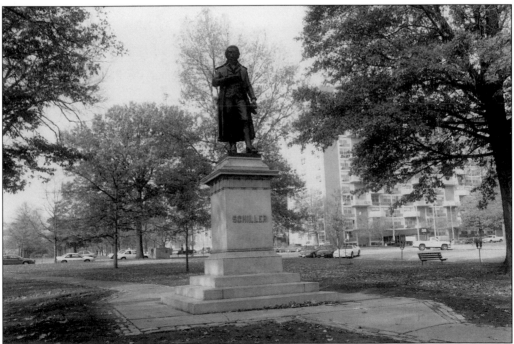

A statue of the famous German poet Schiller was erected on the Gateway Mall leading to Union Station.

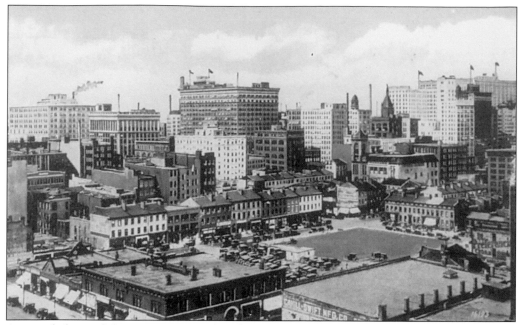

An aerial photo of the city as it existed in the 1920s captures some of its major skyscrapers and other buildings.

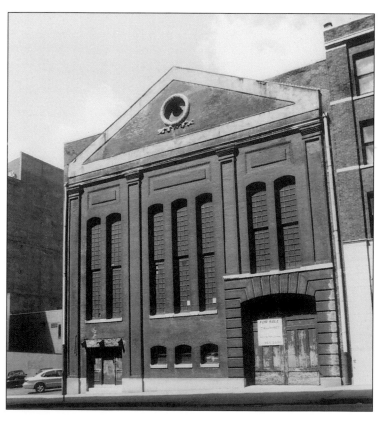

This old-fashioned stable once served Washington Avenue at Eighteenth Street.

A view of the Telephone Building, as it appeared in downtown St. Louis in 1908.

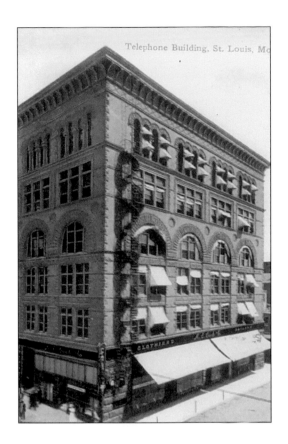

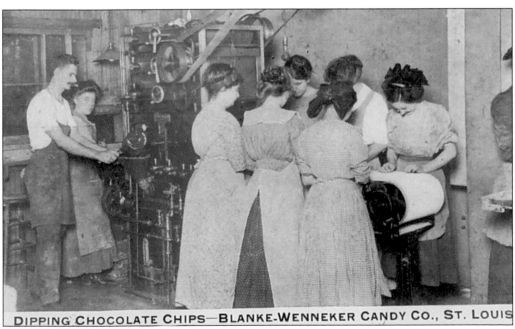

DIPPING CHOCOLATE CHIPS—BLANKE-WENNEKER CANDY CO., ST. LOUIS

As this postcard reveals, female workers and their supervisor are laboring at dipping chocolates at the Blanke-Wenneker Candy Co., c. 1910.

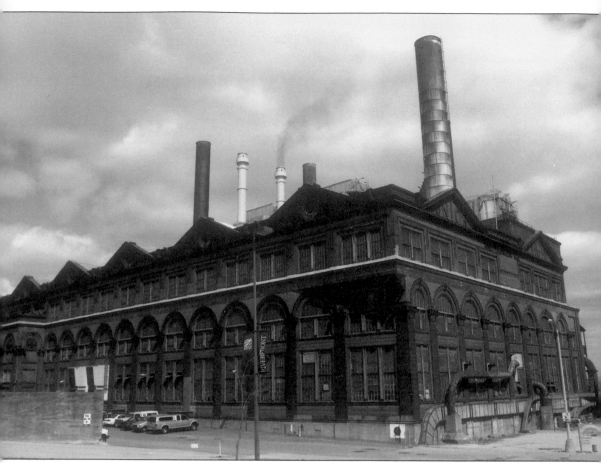

Originally built to supply electricity for the 1904 World's Fair, this steam plant, situated on the Mississippi River, was converted to steam in the late 1920s. Now, as the Trigen-St. Louis Energy Corporation, it still provides electricity and also provides steam heat for many downtown buildings.

This is another early photo of the Missouri Trust and Chemical Buildings.

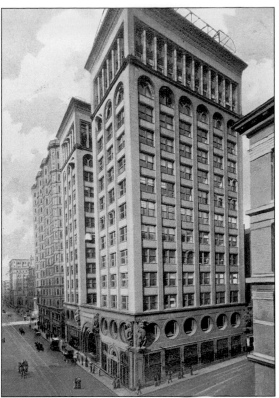

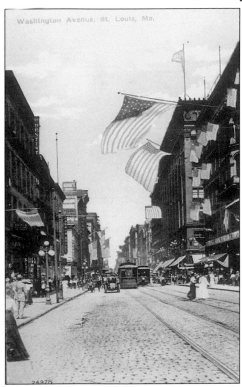

In this postcard scene of Washington Avenue in 1912, the displayed American flags appear to have been added to the card.

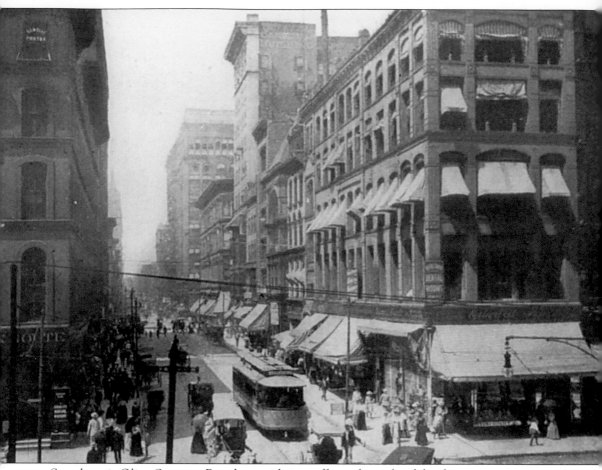

Seen here is Olive Street at Broadway with its traffic and people of the day.

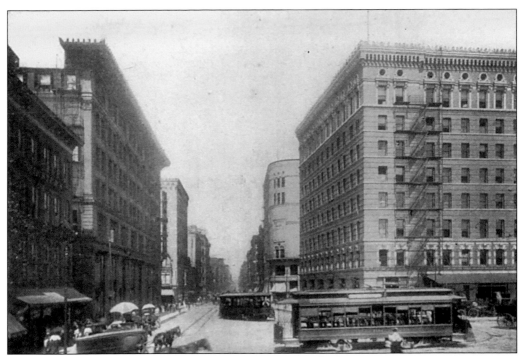

This shot of early Washington Avenue looks west from Third Street.

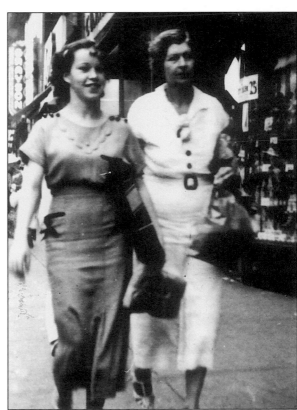

These shoppers appear to be cheerful and relaxed as they walk downtown during the late 1930s or 1940s. For these ladies the Depression does not seem to be a hindrance.

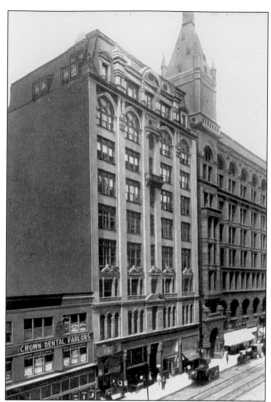

Pictured here are various significant buildings on Washington Avenue around 1908. They include the Burlington and the Odd Fellow Buildings.

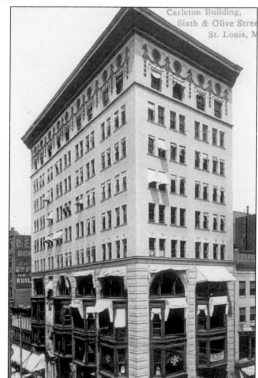

This is a 1908–9 photo of the Carleton Building at Sixth and Olive.

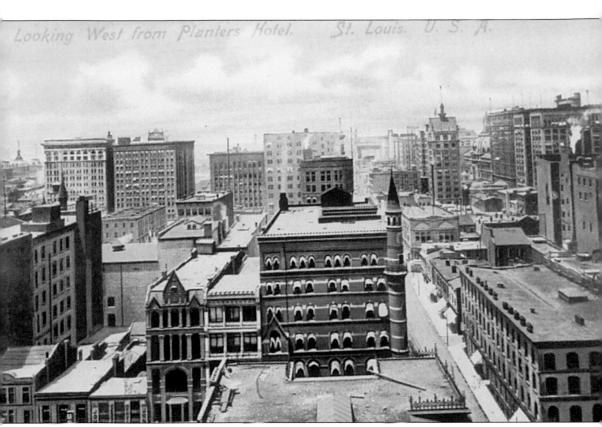

Here is a 1908 shot looking west from the famous Planters Hotel.

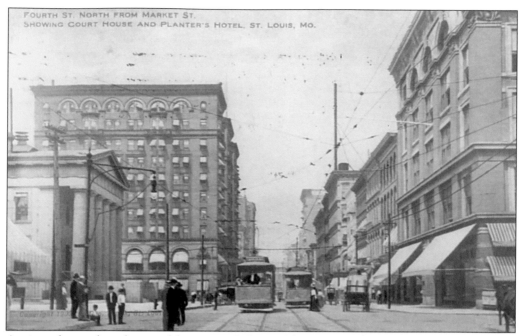

Again we have a broad view of downtown St Louis. This vintage photograph from around 1911 focuses on the trolleys whose tracks filled the downtown streets.

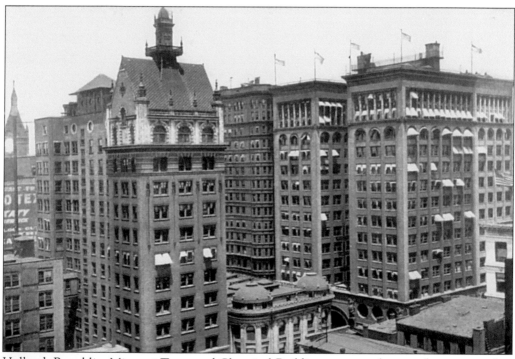

Holland, Republic, Missouri Trust, and Chemical Buildings are seen here as they appeared in 1908 in downtown's most prosperous period.

The Gateway Mall, running from the old Courthouse to Union Station, is by any measure one of the most attractive areas in the city.

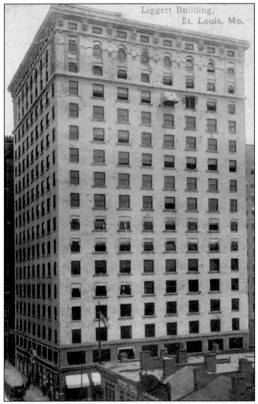

The Liggett Building, of the famed tobacco family, was pictured here in 1911, when tobacco was king in St Louis.

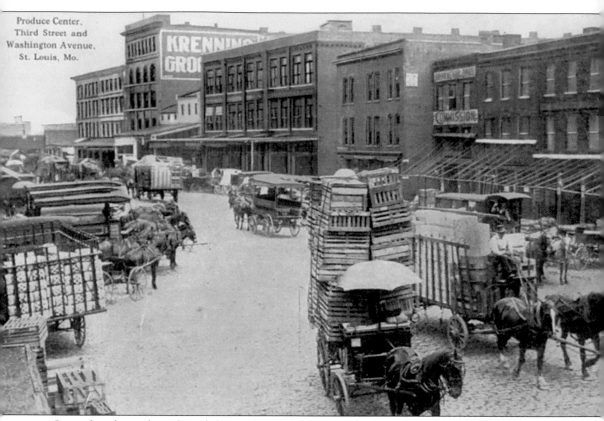

Produce Center,
Third Street and
Washington Avenue,
St. Louis, Mo.

Several early markets dotted the St. Louis downtown cityscape. This is the Produce Center at Third and Washington in 1907.

Washington Avenue is being served by streetcars making a turn in 1908.

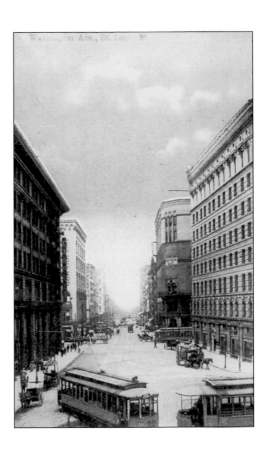

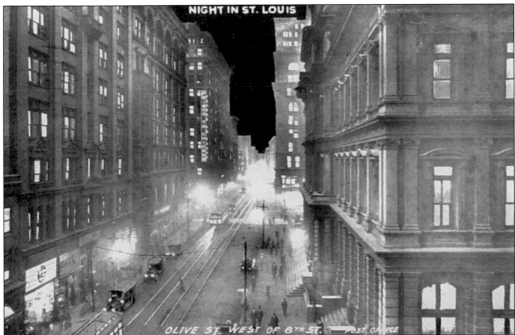

In this 1919 photograph, street lights seem to shine forth in a blazing fashion.

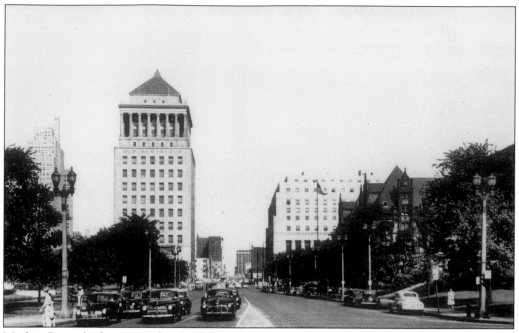

Market Street looks east to the Civil Courts Building and City Hall in the 1940s.

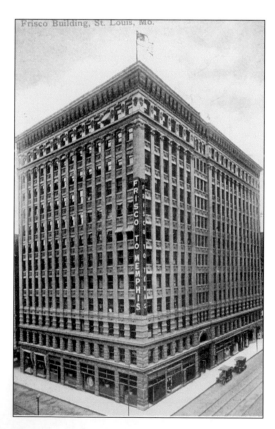

The Frisco Building is seen here as it existed in downtown St. Louis in 1912.

The old post office in 1906 faces the traffic of streetcars passing on Olive.

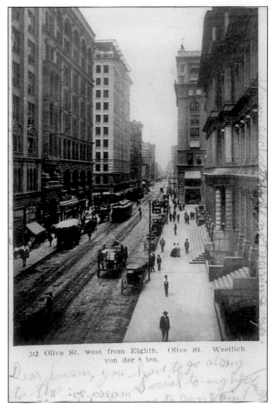

The old post office is pictured here as it looked 14 years later.

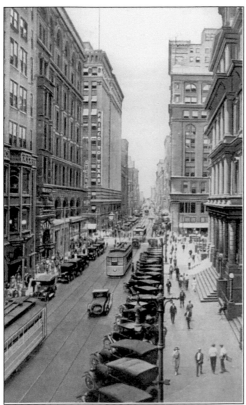

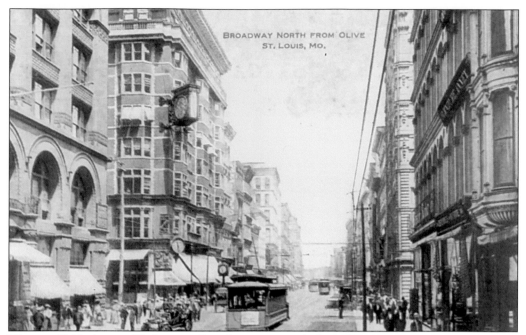

This is a 1910 photo of St Louis at Broadway, just north from Olive.

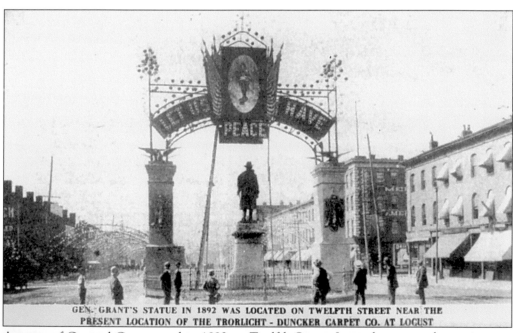

A statue of General Grant stood in 1892 on Twelfth Street. It was later moved to a site near City Hall.

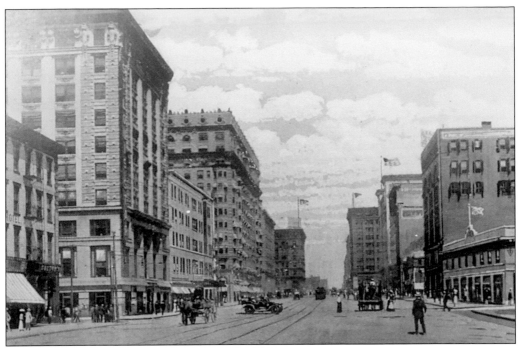

We see here Twelfth Street and Olive in the 1910s.

Here is a view of downtown St. Louis pedestrians during the Depression 30s. Their grave faces seem to reflect the gravity of the times.

The *Post-Dispatch* spent its earliest days in this building.

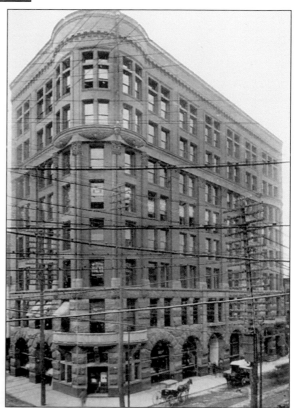

This is how the old *Globe-Democrat* Newspaper Building appeared in 1906.

The St Louis Star lodged here before it merged with the *Times*.

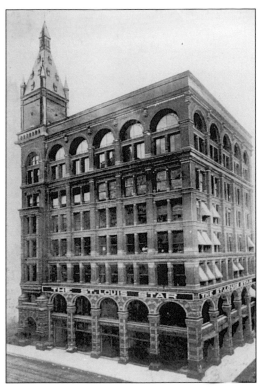

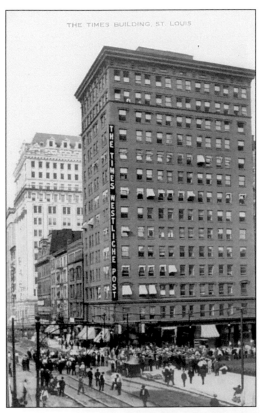

Another important downtown building of its day, the *Times* Building is seen in 1908.

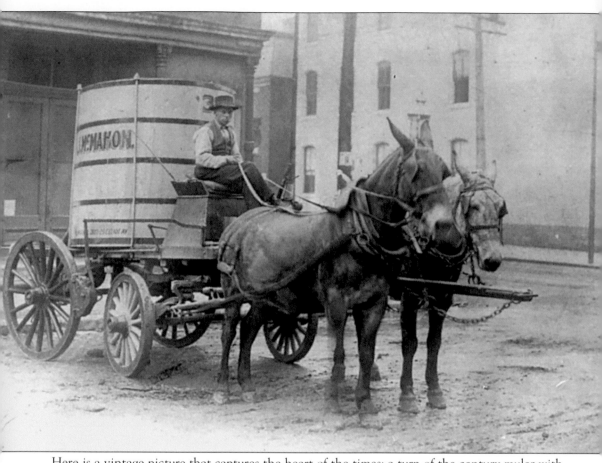

Here is a vintage picture that captures the heart of the times: a turn of the century muler with his cart, dispensing water to settle the dust of downtown streets.

Nine

ENTERTAINMENTS, SPORTS, AND MUSEUMS

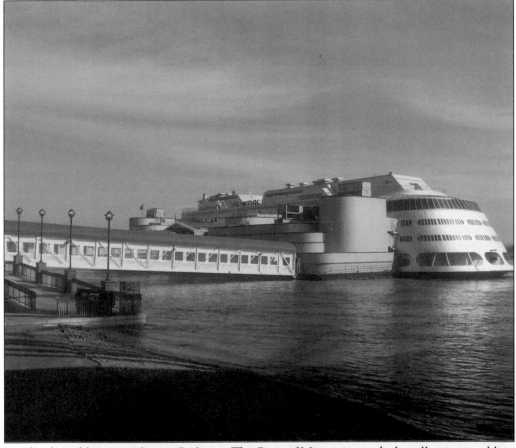

Legalized gambling came late to St. Louis. The State of Missouri passed a law allowing gambling only on designated rivers. The *Admiral*, the long beloved excursion boat, was taken out of retirement and converted to such a new role on the Mississippi.

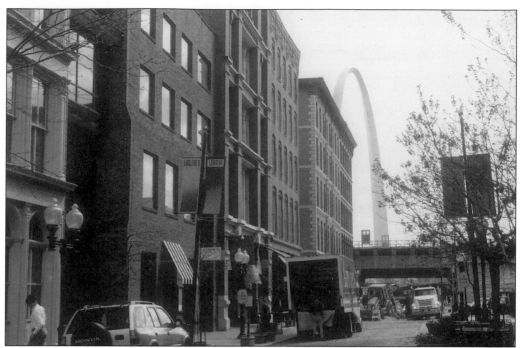

One of the major developments along the river was the entertainment area, called Laclede's Landing. Here, in the midst of rehabilitated, old, elegant buildings, the city has established a pleasure section of downtown St. Louis that attracts tourists of all sorts. It marks the spot, of course, where the founders of St. Louis first landed.

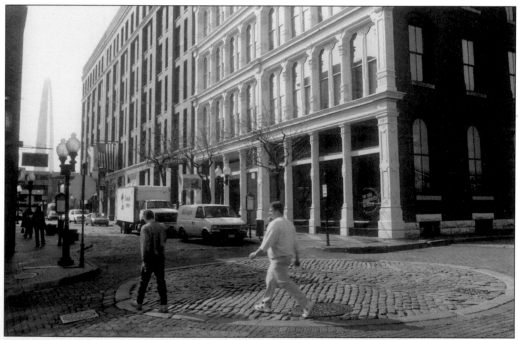

Among the many enterprises instituted on the Landing are such restaurants as the popular "Spaghetti House," which is fronted by a circular water ring for the horses of old.

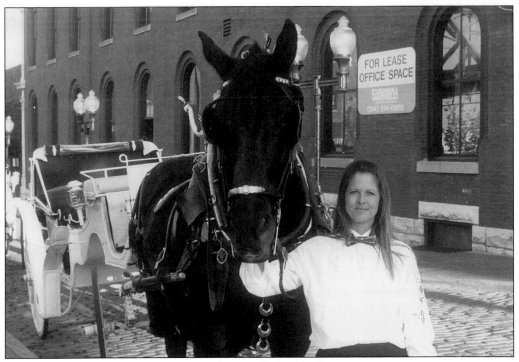

This horse and carriage makes its rounds in Laclede's Landing.

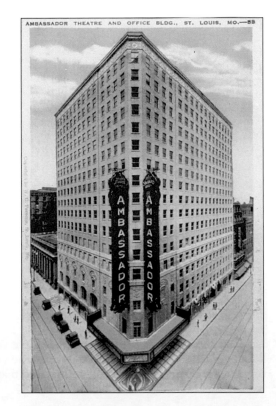

Once this handsome building housed one of St. Louis' best professional theaters, the old Ambassador. Here we see the famed building in the 1920s.

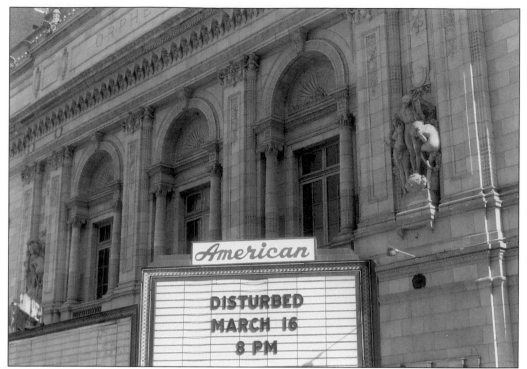

Here we can glimpse above this marquee at the decorative beauty of the American theater as its sign declares the date of its next performance.

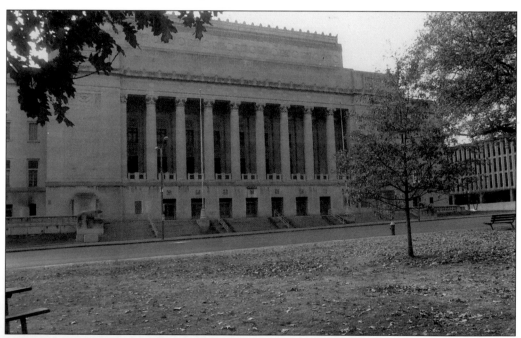

Built originally as part of the WPA administration in 1934, Kiel Opera House was the traditional venue for concerts, conventions, and other attractions for the city. It has been neglected and unused for a number of years.

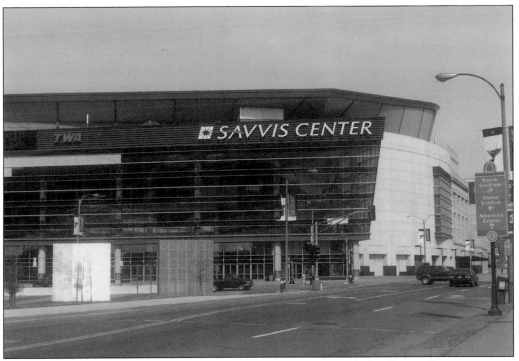

Adjustments to Kiel have recently changed a back area called the Savvis Center, a more modern structure for sports events in particular.

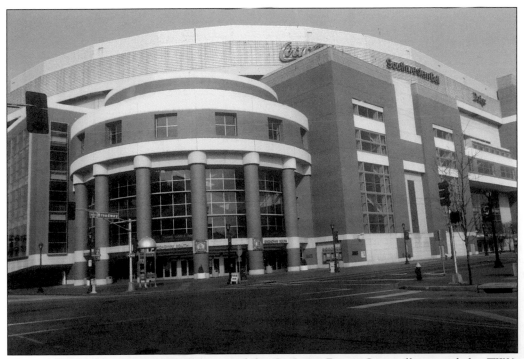

This is the sparkling new football home of the St. Louis Rams. Originally named the TWA dome, it will lose that title with TWA's merger with American Airlines.

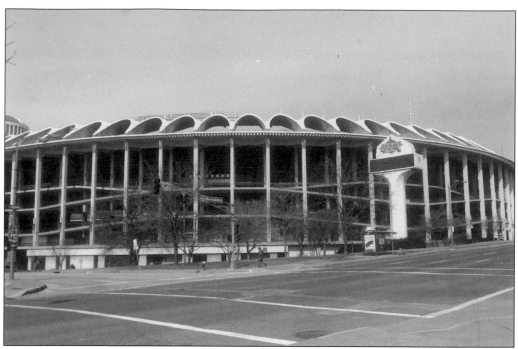

The famous Busch Stadium is seen here. Declared by some to be obsolete, they are inviting the city to replace it with a new stadium.

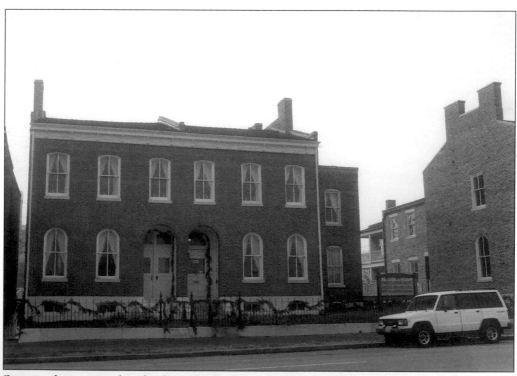

Seen in this postcard is the Scott Joplin House, where the famous ragtime composer, Scott Joplin, once resided.

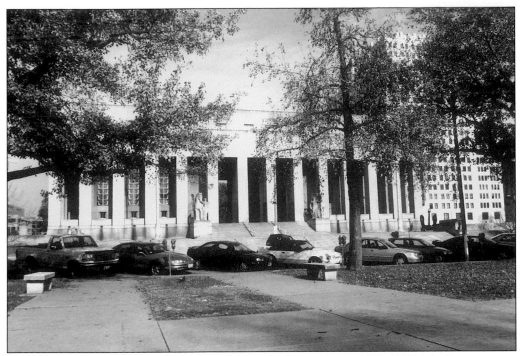

Soldiers Memorial is seen here. Built to honor the heroic dead of World War I, this imposing structure was built during the 1930s. It means to honor all the dead of America's wars.

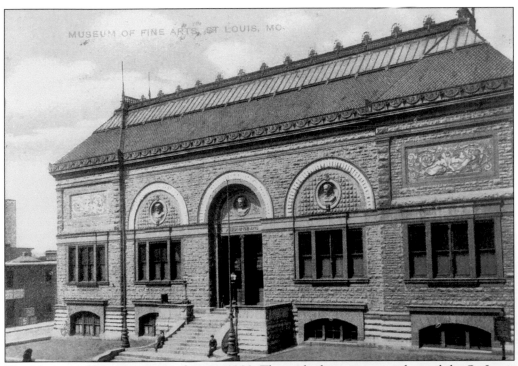

The Museum of Fine Arts is seen here in 1908. This arched structure once housed the St. Louis Art Museum. Later the museum was moved to Forest Park, where it remains today.

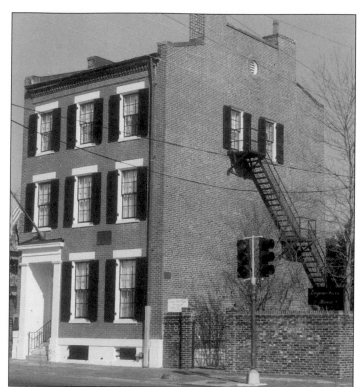

This is the famed abode of the beloved poet Eugene Field, who lived in the city for some years. It has been converted into a toy and memorabilia museum.

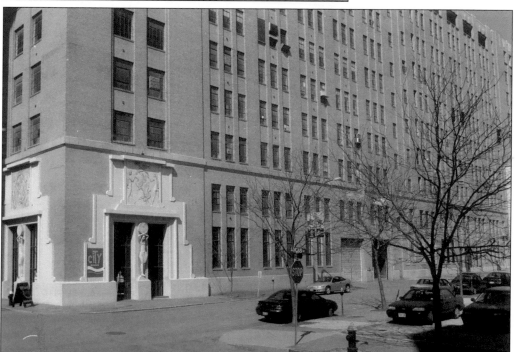

This is by far the most adventurous step taken to revitalize downtown St. Louis. It is the new City Museum. An ingenious romp into the creative imagination, it has resulted in a delightful venue for children and adults alike.

Ten

RENOVATION AND RENEWAL

One of the great problems in reclaiming St. Louis as a major city is the division between those who wish to tear down old structures and replace them with buildings more attuned to the new and those who wish to preserve the historic integrity of the older buildings. They reason that modern buildings will attract more business downtown. The conservationists argue that restoring old buildings with their majestic appearances will do more to attract others than new ones. And so the quarrel goes on…

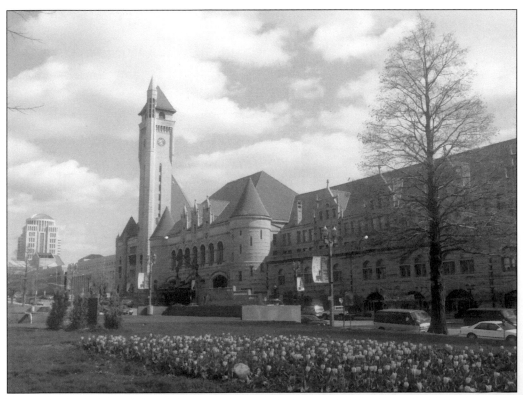

If there were one, the "Ballad of Union Station" would relate the decline and fall of one of the busiest railroad stations in the country. Luckily this fine structure has recently been restored as a shopping mall with stores, restaurants, and a hotel.

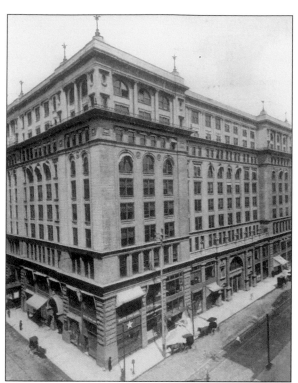

Listed on various rolls as two of the most endangered historic buildings, the Syndicate Trust and adjoining Century buildings are seen as they were years ago.

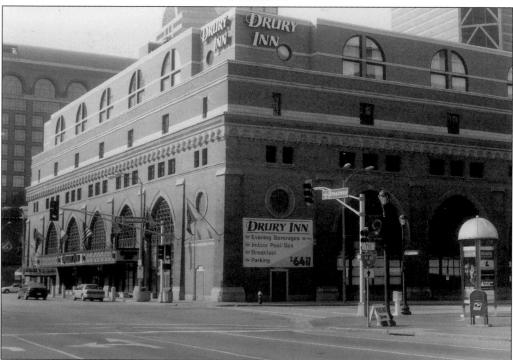

Once a busy market for fruits and vegetables downtown, the building has now been converted into an elegant new Drury hotel. Built by one of the great benefactors of the city, Charles Drury, as one of the series of local hotels created by him, it has added new life to this part of the city.

As indicated, Charles and Shirley Drury seem determined to keep the city alive. Here they have renovated three old buildings to create a special hotel, the Drury Plaza. In the process they have managed to save the 81-year-old, nine-story Fur Exchange, the Thomas Jefferson, and the American Zinc Co. buildings.

Lofts apartments and the old YWCA can be readily seen from this angle of vision.

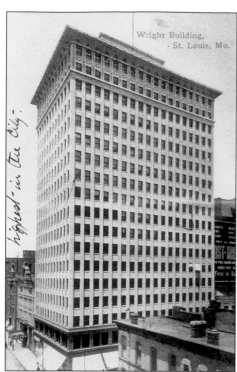

Wright Building, St. Louis, Mo.

highest in the City.

The Wright/Arcade complex, as it existed in 1908, was the highest structure in the city. It now awaits a new life.

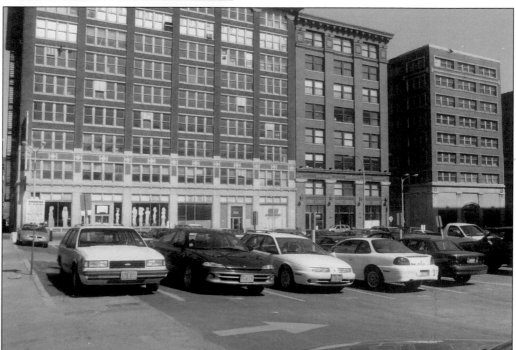

Seen here are the University Lofts, located at 1627 Washington. The once neglected center of many successful businesses on Washington Avenue, the street lay dormant for years. Now it has become a center of a great deal of activity. Lofts of many sorts are sprouting from ancient buildings as young people move into the area.

The good news is that the historic Campbell House, one of the great old-fashioned houses of the city, is now undergoing some vast renovation.

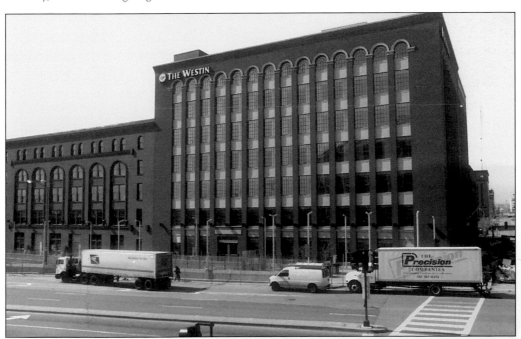

One of the more encouraging signs of a revitalized St. Louis is this old Cupples warehouse, which has been converted into a luxury hotel. Other warehouses in the Cupples complex await renovation.

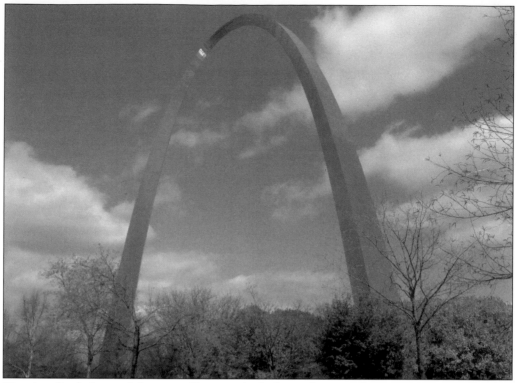

Here is a final photo of the great Gateway Arch. It can be viewed as an ironic reminder that it can become a gateway to St. Charles and other counties, rather than becoming an icon for a fresh new city of development and growth.

BIBLIOGRAPHY

Bartley, Mary. *St Louis Lost*. St. Louis, MO: Virginia Publishing, 1994.

Faherty, William. *St. Louis: A Concise History*. St. Louis, MO: St. Louis Convention and Visitors Center, 1990.

Fifield, Barringer. *Seeing St. Louis*. St. Louis, MO: Washington University Press, 1987.

Hannon, Robert, ed. *St. Louis: Its Neighborhoods and Neighbors*. Photos by Jack Zehrt. St. Louis, MO: 1986.

Larson, Ron. *Upper Mississippi River History*. Winona, MN: Steamboat Press, 1994.

Mehrhoff, W. Arthur. The *Gateway Arch: Fact & Symbol*. Bowling Green Press, 1992.

Primm, James Neal. *Lion of the Valley*. Boulder, CO: Pruett Publishing Co., 1981.

Scharf, J. Thomas. History *of St. Louis City and County*. Philadelphia, PA: Louis H. Everts, 1883.

Stiritz, Mary M. St. Louis: Historic Churches and Synagogues. St. Louis, MO: St. Louis Public Library and Landmarks Association of St. Louis, Inc., 1995.

Williams, Walter and E.W. Stephens. *The State of Missouri*. Columbia, MO: 1904.